BRITAIN IN OLD PH

EAST DEVON

AT WAR

TED GOSLING & ROY CHAPPLE

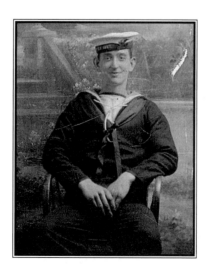

ALAN SUTTON PUBLISHING LIMITED

Alan Sutton Publishing Limited
Phoenix Mill · Far Thrupp · Stroud
Gloucestershire · GL5 2BU

First published 1995

Copyright © Ted Gosling & Roy Chapple, 1995

Cover photographs: (front) firemen searching
the wreckage of Walton's Store, Exmouth,
1941; (back) bomb damage in The Parade,
Exmouth, 1941. Title page: Stanley Morgan
from Axford, who served in the Royal Navy for
thirty years.

British Library Cataloguing in Publication Data.
A catalogue record for this book is available from
the British Library.

ISBN 0-7509-0914-5

Typeset in 9/10 Sabon.
Typesetting and origination by
Alan Sutton Publishing Limited.
Printed in Great Britain by
Hartnolls, Bodmin, Cornwall.

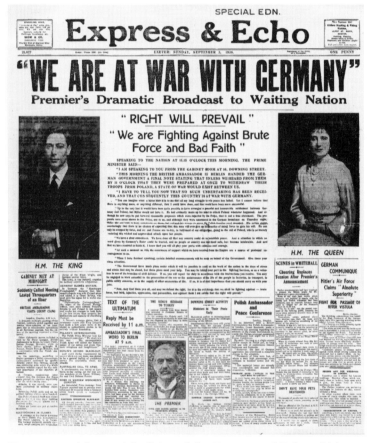

Front page of the special edition of the *Express and Echo*, which was
published on Sunday, 3 September 1939.

Contents

Introduction

The theme of this book is a chronicle of the various wars that have occurred in East Devon throughout the centuries. Perhaps surprisingly, there have been many invasions and occupations, starting with the Celts in Iron Age times, followed by the Roman conquest and occupation, and then the Saxons, the marauding Danes and the Normans. Then came a period of building defences against the Spanish Armada, the French, the Dutch and even Turkish pirates.

The Prayer Book Rebellion of 1549 made its mark on East Devon soil when the peasants were heavily defeated. The Civil War was particularly bloody in this area and many of the more important castles and houses were destroyed during the fighting. Later, in 1685, the Duke of Monmouth landed at Lyme and made his way via Taunton to Sedgemoor where he was soundly defeated; many East Devon men who had rallied to his cause were killed in the battle, the survivors being hunted down and tried by Judge Jeffries and either executed or transported. There was again much activity along our coast during the Napoleonic Wars. The local Militia was raised to keep the peace; the yeomanry cavalry was formed and coastal artillery units were sited at strategic points to guard our coast. Many of these installations remained in place until the First World War.

It is only in more recent times that we have had the benefit of photography and so naturally the emphasis in this book has been on wartime events of the last hundred years or so.

During the Second World War Devon became one of the most militarily active counties in the United Kingdom. The county suffered from bombs, land-mines and shells. Exeter and Plymouth were blitzed and other towns were attacked. Despite all this, the inhabitants endeavoured to carry on their everyday life as normally as possible.

The first major event to affect them was the evacuation of Dunkirk in May 1940. The unexpected stationing of troops, including the Kings Own Infantry regiment, in East Devon brought home to local residents the fact that things were becoming very serious, and an invasion by the Germans was imminent. The people became used to seeing a strong Army presence in the area, while the RAF set up permanent camps and built the advance radar station on Beer Head. The aerodrome at Honiton Clyst was taken over by the RAF and new airfields were constructed at Dunkeswell and Smeatharpe. The Navy was responsible for defence work in the river estuaries while an RAF air-sea rescue unit was established at Lyme Regis, just over the border in Dorset. The Observer Corps was formed of local volunteers to report on unidentified aircraft crossing the coast, and the Local Defence Volunteers, later the Home

Guard, was organized to cover the Devon area, carrying out regular day and night patrols in conjunction with the Special Police and Coastguards.

Coastal defence guns, several of First World War vintage, were erected at prominent points along the coast. The appearance of anti-aircraft guns, searchlights and sound locators in fields or on the hills was the next development, while the Army hastily dug trenches, laid mines, and erected scaffolding and barbed wire entanglements along the pebble beaches. Concrete block-houses were built along likely paths of advance by invading forces. Military activity now reached its peak.

One night there was an invasion scare when the church bells rang out and all households were woken to prepare for an imminent invasion. After the successful evacuation of Dunkirk the Battle of Britain commenced, and from then on East Devon was subjected to air raids, with local towns suffering serious damage and casualties. People spent many nights sheltering under their stairs or in Anderson shelters in their back gardens. Aircraft from both sides crashed or force-landed in the area. At this time allied Czech and Polish troops, and also a unit of the Free Spanish Army were successively stationed at Warners Camp in Seaton, once the interuees had gone, with the overflow being billeted in local households.

As D-Day approached the area again became active as American troops were dispersed in the country lanes and woods. When the great day came, all the troops suddenly disappeared overnight. The last air raid in East Devon had been on Exmouth in February 1943, and after the departure of the Americans the local population were able to relax.

After five years of suffering by both the military and civilians alike, the final task was the demolition of the anti-tank defences, the removal of miles of barbed wire along the coast and the clearance of the mines from the beaches. Most of the pill boxes were allowed to remain, and today they stand as memorials to the traumatic days of the Second World War.

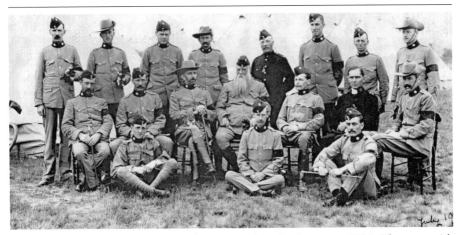

Officers of the 3rd Volunteers Battalion Devonshire Regiment, *c.* 1904. The man with the splendid beard (seated centre) was the Rt Hon Sir John Henry Kennaway Bt, MP for the East Devon and Honiton Division. He was also a Lieutenant Colonel, commanding the 3rd Volunteers. William Henry Head of The Wessiters, Seaton, is seated on the ground on the right.

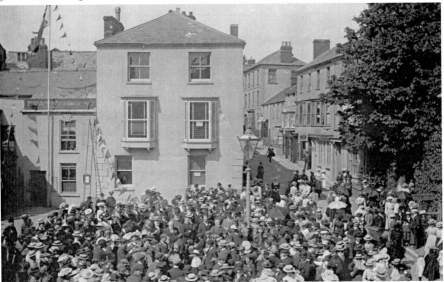

The interest of East Devon in 1900 was focused on the Boer War in South Africa. The progress of this war was watched with deepest anxiety and when news arrived of the relief of Mafeking celebrations were held throughout the country. Many volunteers from Seaton, Sidmouth, Exmouth and neighbouring villages had bravely volunteered for service at the front and had marched off to war to the tune of 'The Soldiers of the Queen'. This was the scene in the square in Seaton on Peace Day, Monday 2 June 1902. The news of the peace had reached Seaton the previous night and on the Monday the streets assumed a festive appearance, the town echoing with the noise of tumultuous cheering and the ringing of the church bells.

EARLY WARS
THROUGH THE AGES

East Devon has been at war many times through the ages. In the Iron Age the Axe estuary was the frontier between the Dunmonii of Devon and the Durotriges of Dorset. Axmouth harbour, protected by the hillforts of Hawkesdon and Musbury, was one of the most important harbours in the west of England and one of the safest anchorages.

It remained a significant port in Roman times and was used by the Roman General Vespasian, who commanded the famous Second Legion, during his campaign to conquer the west. Axmouth harbour served as Vespasian's military base for the siege of Exeter, and later it marked the end of the Fosse Way which ran through Ilchester, Bath and Leicester to Lincoln and the east coast, along a diagonal frontier established by the Romans across England.

The Romans built two forts in Seaton to defend the port. The first, situated in a field below Honeyditches, was constructed with oval earthbanks. The second and later fort was a more permanent structure, built of squared stone on the summit of Bunts Knoll.

In AD 612 the Battle of Bindon was fought above Axmouth between the British and the advancing Saxons. The British defenders of Hawkesdown were defeated, with over two thousand dead, a significant number in those days. The outcome was the Saxon occupation of the Axe valley and the rest of East Devon.

Later, in the tenth century, the marauding Danes appeared off our coast. In AD 957 they landed an army under Anlaf in the Axe estuary, and advanced up the valley towards Axminster. Here they met the Saxons in battle at Warlake, near the village of Musbury. Despite the deaths of seven Saxon earls, who were buried in the Minster Church at Axminster, King Athelstan was the victor and the Danes took to their boats and departed from our shores.

In 1191 soldiers going on the Third Crusade under King Richard I used

Axmouth Harbour as one of their two ports for embarkation to the Holy Land.

During the reign of Henry VIII another Seaton fort was built, this time in the centre of the seafront. Its design was similar to that of St Mawes in Cornwall and on its completion in 1544 the king landed on Seaton beach to inspect it. It became derelict after the defeat of the Spanish Armada in 1588, but was rebuilt in 1627 with extra ordnance for the defence of the valley and harbour. It was renovated again in 1688 during the Dutch Wars and yet again in 1794 during the Napoleonic Wars. A Martello Tower was built on the Burrow a little later, with two 32-pounder guns manned by the local volunteers of the Seaton and Beer Artillery. The fort was finally demolished in 1848 when Sir Walter Trevelyan, then Lord of the Manor, built a roadway along the seafront as part of his ambitious development scheme for Seaton.

The Prayer Book Rebellion of 1549 was the next important occurrence in East Devon. The peasants from Cornwall, marching towards London, were joined by others in Devon, and met the Royal forces who barred their way before they reached Honiton and battle was joined at Fenny Bridges. The peasants were defeated and pursued back to Clyst St Mary. The subsequent Battle of Clyst Heath was more bloody, and culminated in the massacre of over nine hundred prisoners by the Royal forces.

At the turn of the sixteenth century the East Devon coast was repeatedly raided by Turkish pirates who operated in the English Channel.

The Civil War began in 1642 and this soon affected East Devon. On the whole Devon was more parliamentarian than royalist, and the leaders in the struggle against the king were powerful men like Lord Rolle, the Drakes of Ashe and the Erles, Strodes and Northcotes. On the royalist side were the Poles of Shute, the Aclands and the Fulfords. East Devon suffered severely during the local conflicts between the autumn of 1642 and the spring of 1646. Several country houses were burnt, including Stedcombe at Axmouth, Ashe at Musbury, Shute Manor and Colcombe Castle. On top of this there was plundering by both sides: the parish of Uplyme lost three thousand sheep, required for food when the Parliamentarian stronghold of Lyme Regis was besieged by the royalists. The estates of the landlords, both large and small, on either side had all been stripped. In the towns the woollen merchants and shopkeepers lost large stocks of goods. Colyton was one such town that suffered in this way.

When William of Orange landed at Brixham in 1688 some of his transports discharged their cargoes at Exmouth.

In 1784 William Pitt had become prime minister, and his ambition was to preside over a period of peace. Five years later the French Revolution broke out and in 1793 the French Government declared war against England. On 15 May 1794 the first Yeomanry Regiment was formed in Devon, when Sir Stafford Northcote raised the 1st Devon Troop around Pynes near Exeter. The second troop was the East Devon Troop of Volunteer Cavalry, raised by Sir John de la Pole of Shute, and based in Axminster. The first officers were Captain Sir John de la Pole, Lieutenant William Oke and Cornet Matthew Liddon, in charge of fifty-seven other ranks. Upon approval from the Secretary of State, the unit was

fitted out with uniforms and equipment, including saddles and military bridles, the men's saddles being priced at 30s each. Within two years a third troop was raised, again in East Devon, and Sir John de la Pole was promoted to Major Commandant. In June 1797 the troops of the Royal East Devon Yeomanry Light Dragoons were reviewed on Shute Hill. Their major role was now for home defence, as there was civil unrest in the country at that time. Wages were low, food was scarce and dear, and there was much impatience over Parliamentary representation. The yeomanry was called out several times to enforce civil power and to escort important personages or royalty in their journeys through the county. For many years the yeomanry was responsible for keeping the peace, until eventually an efficient police force was formed in 1857. At the same period the militia was increased, and artillery units formed for coastal defence. Lord Rolle of Bicton was designated Major Commandant of the Beer and Seaton Artillery, which had batteries on Beer Head, on Gun Cliff at Beer and on the Burrow at Seaton. Other batteries were located along the coast at Sidmouth. Another artillery company was set up in Exmouth in 1860 under Captain Edward Divett MP, of Bystock, and the first guns were installed on a site near the present lifeboat museum. This battery was demolished in 1908, but a smaller battery sited on the Maer survived until later. The Exmouth Volunteers held frequent drills and manoeuvres on Woodbury Common.

The Royal East Devon Yeomanry was disbanded in 1838, as the troops were no longer essential for the preservation of peace, but the Volunteers were later reformed and mobilized for the Boer War in South Africa, where they served with distinction.

The First World War did not affect East Devon directly, but after mobilization a large number of men from the area went to serve in the armed forces; many of them never returned. Wartime incidents were confined largely to actions at sea.

In October 1914 an English merchant ship, the SS *Oakby* of the Ropner Line, captained by Francis Bartlett of Beer, and with a complete crew of Beer men, most of whom were related, was intercepted in the English Channel by a German U-Boat which surfaced and ordered the crew to take to their boats. The submarine then sank the ship by torpedo, much to the fury of Capt. Bartlett. As a direct result of this incident, a Question was asked in Parliament as to whether it was the policy of the German government to sink unarmed merchant ships. This was the opening shot of the U-Boat War. (In the second World War, Bartlett's son Capt. Edward Bartlett, Commodore of the Ropner Line, was involved in many Atlantic convoys and saw the loss of many merchant ships through German U-Boat activity.)

The biggest loss was the battleship HMS *Formidable* on 1 January 1915. A pre-war Dreadnought, she carried a crew of 790 officers and men. Struck by a torpedo in the early hours of the morning, some miles off the Devon coast, she sank an hour and a half later. Owing to the rough seas and intense cold, only about two hundred of her crew survived the night.

In 1917 four large steamers were sunk by enemy action in Lyme Bay. HMS *Clyde*, a trawler requisitioned by the Admiralty, and the Liverpool steamer *Bona* were torpedoed and sunk off Sidmouth.

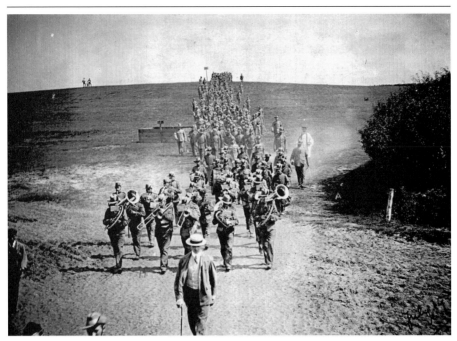

The 3rd Volunteers Battalion Devonshire Regiment on manoeuvres on Woodbury Common, 1904.

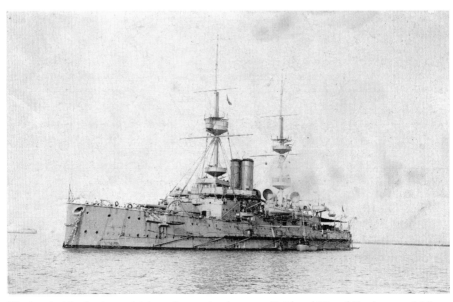

The battleship *Jupiter*, which took part in the great Spithead Naval Review on 26 June 1897, anchored off Beer in 1907. Many local people visited this great battleship.

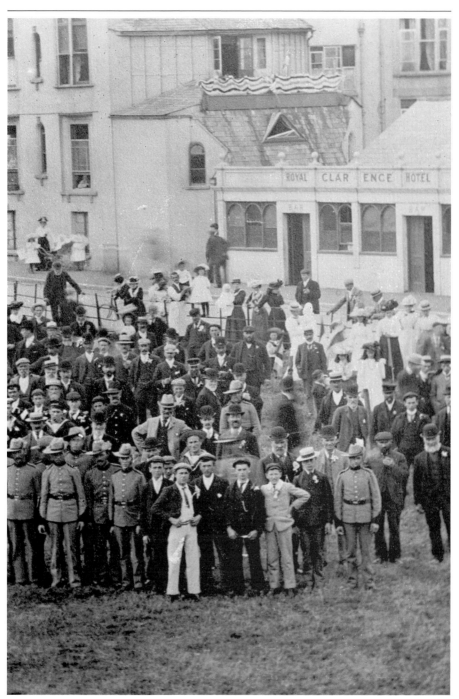

Boer War Peace Day celebrations at Seaton, Monday 2 June 1902 (see p. 6).

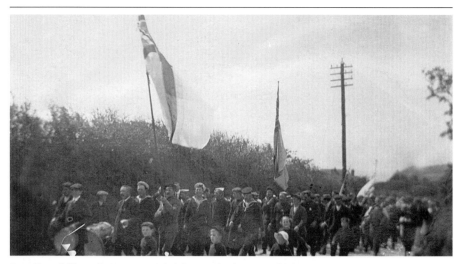

Beer Royal Navy Reserve men joining up in August 1914.

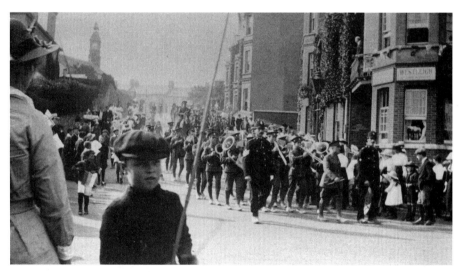

Seaton, 1914. At the outbreak of the First World War, the normally quiet seaside town of Seaton became a scene of continuous bustle and excitement. The steady enrolment of men proceeded week by week; here some of the first to join the Devonshire Regiment are marching down Sea Hill during the late summer of 1914. We do not know how many of them came back, although we know only to well that the best of their generation died, and those who did return found England had changed beyond recognition. Over two hundred men from Seaton served in the war, and of these twenty-four made the supreme sacrifice. Their bodies lie in many lands, beneath many seas, but all their names are recorded on the memorial cross which stands by the entrance to the parish church, reminding all future generations of what they gave, fighting for a cause they believed would bring a better world.

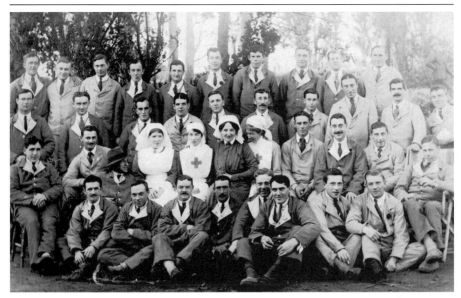

Staff and patients at Ryalls Court, Seaton, which became a Military Hospital during the First World War. Dr Tonge from Beer is sitting in the middle of the front row. The nurses with the red crosses on their uniforms were members of the Voluntary Aid Detachment. They were very popular with the convalescing soldiers who nicknamed these angels with red crosses 'Very Artful Darlings' or, less respectively, 'Victim Always Dies'.

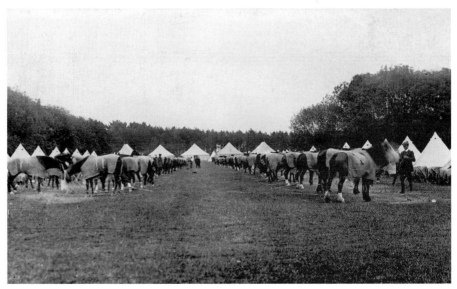

The Royal 1st Devon Yeomanry in camp at Rousdon just before the First World War.

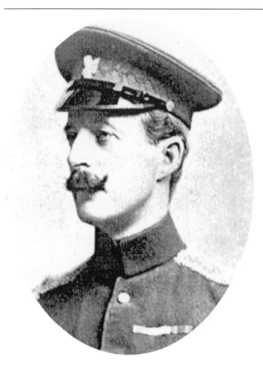

Colonel John Edmund Heugh Balfour DSO, JP, of The Manor, Sidmouth, *c.* 1905. Colonel Balfour was the last Lord of the Manor of Sidmouth. He was born in 1863 and at the time of this photograph was Colonel Commanding the Royal 1st Devon Imperial Yeomanry. His distinguished military career included service in South Africa from 1899 to 1900. He was Mentioned in Despatches with six clasps and was awarded the DSO. He died in 1952.

Colonel Michael Alexander Rowlandson. Born in India in 1841 he took part in the Abyssinian Expedition in 1867–8 (for which he received a medal), the Egyptian Exposition of 1882 and the Battle of Tel-el-Kebir for which he received a medal and clasp (the Bronze Star). He was Controller of Military Accounts in the Punjab until his retirement in 1894, after which he lived in Budleigh Salterton. During his time in Budleigh Colonel Rowlandson took a great interest in all local matters.

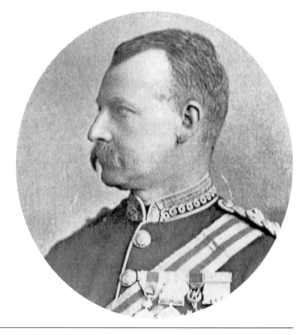

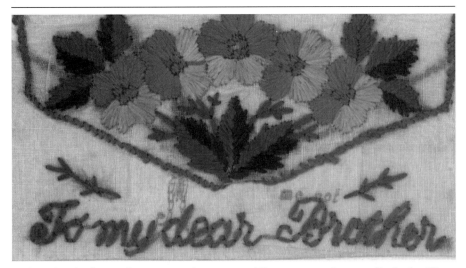

Embroidered silk envelope postcards, *c.* 1916. These two cards are typical of millions that were posted by the troops in France to relatives and friends during the First World War. The majority of them were made in France and Belgium, and they were treasured and carefully preserved by the people who received them.

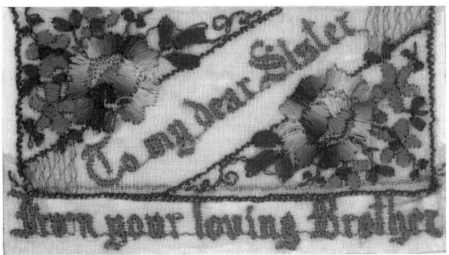

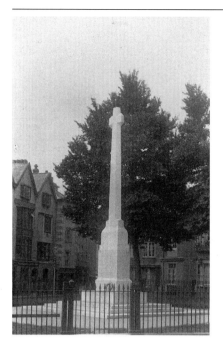

The Devon war memorial in the Cathedral Yard, Exeter. This memorial was unveiled by HRH the Prince of Wales on Whit Monday 1921. It consists of a Dartmoor granite cross on a plinth approached by three steps. It commemorates the 11,601 Devon men and women killed during the First World War.

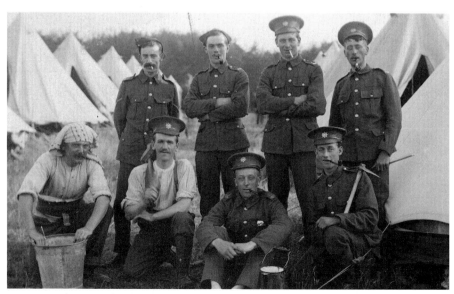

Army camp at Rousdon, *c.* 1915.

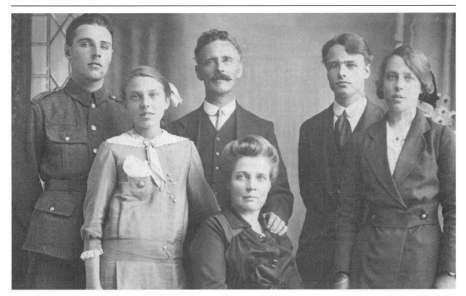

Frank Akerman (in uniform) with his family in 1915. This family founded the local ironmongery business in Seaton. Frank joined the Royal Engineers in 1915 and saw service in France. A dispatch rider with the rank of corporal, he was killed in France on 22 August 1918 during an air raid and is buried at Duisans.

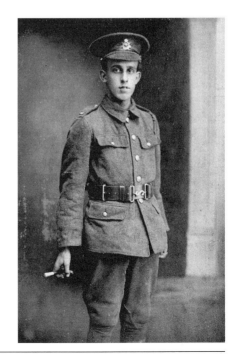

John Gosling lied about his age – he was seventeen – so that he could join the Army during the First World War. During his period of service he went to France and India. He was born in Luppitt and died in Seaton in 1967.

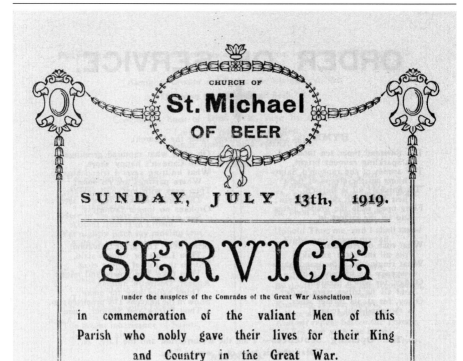

The Order of Service sheet used at St Michael's Church, Beer, on Sunday, 13 July 1919 in a commemoration service for the men from that village who gave their lives in the First World War. A particularly black day for Beer was 31 May 1916 when five young men from the village lost their lives in the Battle of Jutland.

The order of proceedings for the unveiling of the Seaton war memorial on Sunday, 13 November 1921. On that day members of the Seaton UDC, ex-servicemen, VADs, schoolchildren, Boy Scouts and Girl Guides assembled on the sea front, marshalled by Mr W.H. Head, and paraded through the town to the parish church.

But the soul in contemplation
 Utters earnest prayer and strong,
Bursting at the Resurrection
 into song.
Soul and body reunited
 Thenceforth nothing shall divide,
Waking up in Christ's own likeness
 satisfied.
Oh! the beauty, Oh! the gladness
 Of that Resurrection day,
Which shall not through endless ages
 pass away.
On that happy Easter morning
 All the graves their dead restore;
Father, sister, child and mother
 meet once more.
To that brightest of all meetings
 Bring us, Jesu Christ, at last:
By Thy Cross, through death and judgment,
 holding fast. Amen.

Mr. E. C. Meade, C.C., will on behalf of the Town ask Mr. C. C. Gould (Chairman of the Seaton Urban District Council) to unveil the Cross.

Mr. C. C. Gould will then unveil the Memorial.

The Vicar, the Rev. R. S. Robinson, will then Dedicate it.

TO the honour and glory of Almighty God, in the faith of a joyful resurrection, and looking for the mercy of our Lord Jesus Christ, we dedicate this Memorial in loving memory of :—

Francis L. G. Akerman	Reginald T. Hooper
Colin Allardyce	Percy Inge
Harry Allardyce	William Jones
Percy C. Ball	Reginald Mortimer
William Carslake	Walter N. Newton
George Carslake	James H. Newton
Alfred L. Dommett	George T. Northcott
Thomas Fry	Arthur J. Northcott
Reginald W. Gosney	Wilfrid G. Oldridge
William G. Gush	Arthur P. Palmer
Reginald P. Gigg	William Perry
Sidney F. Gigg	William G. Real
Alfred J. Green	Richard C. Sutton
Charles W. Groves	Charles C. Trineman
Cyril Holmes	Eugene Trevett
William Haymes	Robert White

The names of the men from Seaton who were killed in the First World War were listed in the order of proceedings.

Private George Morgan from Axmouth was wounded in the First World War, while serving in France with the 2nd Devons.

Harold Chapple, seen here in his boat at Beer, *c.* 1940, served for most of his life in the Royal Navy. He became a Chief Petty Officer (Gunnery), serving on many warships and at the Battle of Jutland. Two of his brothers were also Chief Petty Officers and three other brothers also went to sea.

Section Two

INDUSTRY

Most local industries of East Devon continued throughout the Second World War, but the emphasis was on war production. Early in the war an ammunition factory was established at Branscombe when the owner of a London factory who had secured a government contract moved his factory's machinery to the Nestlés factory in Branscombe Square. The production of shell fuses and aircraft components increased and at one time 114 people were employed working 12-hour shifts. The shell fuses were loaded into a van and delivered to Seaton railway station.

At Beer, the stone quarries were used by the Admiralty as an ammunition store, with the ceilings of the many tunnels being lined with asbestos sheeting. In the centre of Beer village, the large motor garage belonging to C.R. Good & Son was requisitioned and taken over by the Gundry Company at Bridport. It was used as a factory for making all types of nets for the Admiralty. Outwork was organized in the fisherman's cottages around the village, and both men and women produced hand-made nets. Shands came down from London and took over half of the Axminster Carpets factory, manufacturing machine tools and printing type, while carpets were still woven in the other half.

Farmers were encouraged to produce more food and were helped by the land girls of the Women's Land Army, who ploughed and harvested to help keep the nation from starvation. Children from the local schools were employed to pick up potatoes in the fields, while the fishermen along the coast continued to carry on their hazardous occupation.

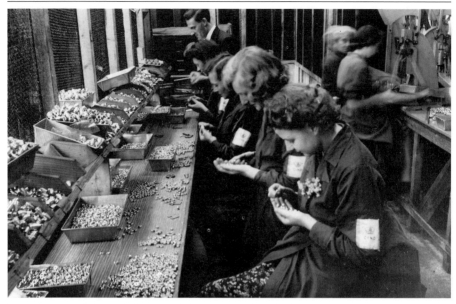

On 14 November 1940 Ernest Bevin, Minister of Labour and National Service, said that women were needed and would be trained side by side with men in skilled work as munition workers. The ladies pictured here in 1943 worked in the secret wartime factory at Branscombe which produced millions of shell fuses and aircraft components.

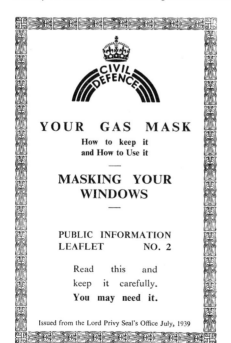

This public information leaflet concerning advance preparations for a possible emergency was issued by the Lord Privy Seal's Office in July 1939. Taking care of your gas mask and blacking-out of windows would become vital in the event of war.

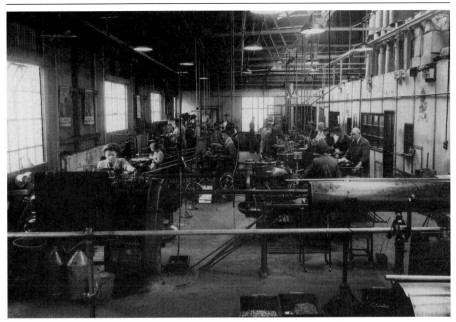

Interior view of Nestlés Munitions Factory, Branscombe, *c.* 1943. On the outbreak of war new factories for the munitions drive were soon planned and Sydney Pritchard and his brother William won a contract to produce shell fuses and aircraft components. Their factory in Holloway, North London, was moved to the garage in Branscombe Square.

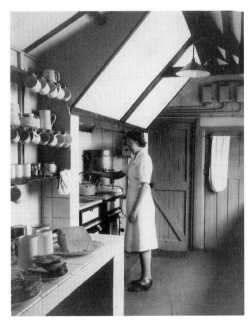

The canteen at Nestlés Munitions Factory, Branscombe, *c.* 1943. Then as now a cup of tea was always welcome, and pictured here in this spotless kitchen is a member of the canteen staff preparing mugs of tea and cheese sandwiches for the factory workers.

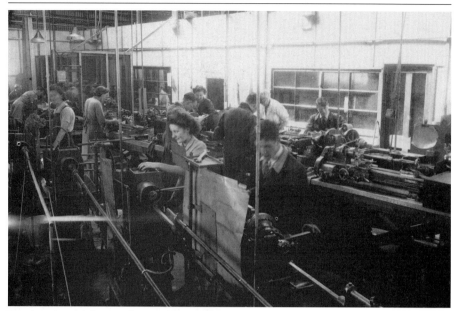

Interior view of the Nestlés Munitions Factory at Branscombe, *c.* 1943.

The Nestlés Munitions Factory canteen, Branscombe, *c.* 1943.

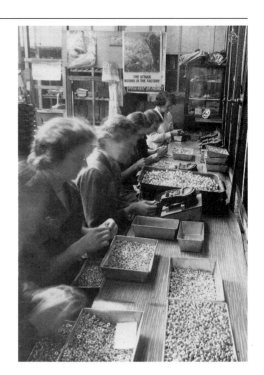

Nestlés Munitions Factory, Branscombe, *c.* 1943. The women workers laboured hard day and night, turning out shell fuses and aircraft components, while a team of women inspectors supervised quality control. This factory made an important contribution to the war effort.

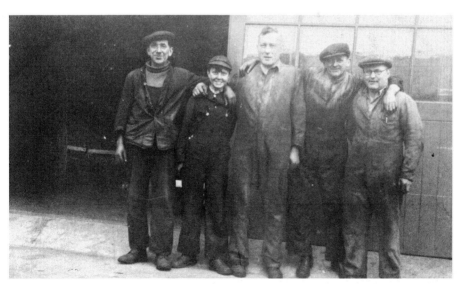

Frank Elston (right) with the war production team at Helliers Garage, Honiton, during the Second World War.

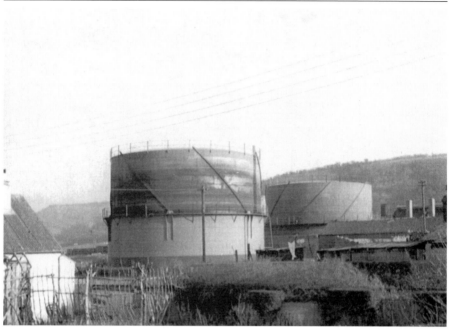

Seaton gasometers, *c.* 1942. The supply of gas was important to the Home Front during the dark days of the Second World War.

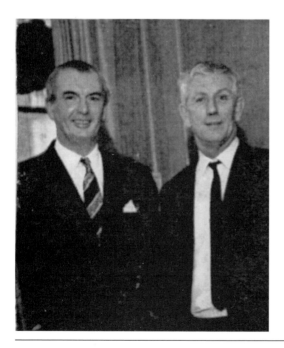

By the early summer of 1939 it had become obvious there was going to be a war. The staff at the Express Dairy Co. at Seaton Junction were joining the voluntary services. On 3 September they stood in the Egg Dept to hear Prime Minister Neville Chamberlain announce on the radio that Britain was at war with Germany. Mr G. Laverick and Mr W. Grissenthwaite, both trainers from Head Office, immediately returned to London and joined the Armed Forces. Pictured here are Messrs G. Laverick and W. Grissenthwaite at a post-war staff reunion.

THOSE WHO
SERVED

Many people have served their country in the Armed Forces through the ages, especially during the two World Wars. In every town and village war memorials have been erected to remember those who lost their lives. All the churches have their Rolls of Honour. The county of Devon war memorial is situated in front of Exeter Cathedral, and was unveiled by the Prince of Wales in 1921. Designed by Sir Edwin Lutyens, RA, the memorial commemorates the 11,601 Devon men and women who died in the First World War. Later the fallen of the Second World War were added. The Rousdon war memorial, on the main road opposite the entrance to Allhallows College, is certainly unusual, and probably unique, in that it doubles as a signpost.

John George White, 1914. George joined the Royal Engineers in 1914 as a volunteer at the age of forty. He served in France but was returned to England where he died in hospital at Chatham in 1915. His name is recorded, with that of his brother Victor Mark White, on the war memorial at Shute.

Victor White, pictured here *c*. 1917, was born in 1898. He served on the Western Front in the First World War with the Royal Naval Division, who fought in the trenches. He was badly gassed but survived to start up a haulage business in the Shute area. He was one of the first collectors of milk for Express Dairies at Seaton Junction. His father, George White of the Royal Engineers, also served on the Western Front. Victor died in 1976.

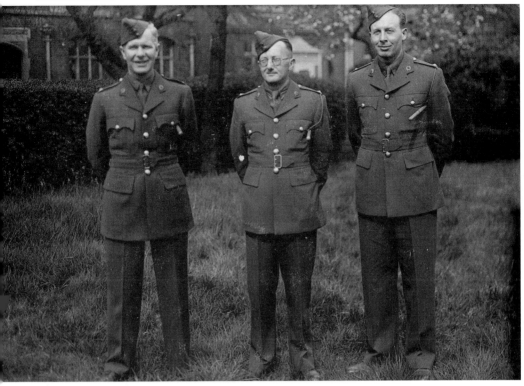

Captain E.A. Stentiford (centre) with two colleagues, having just passed out successfully at OCTU in 1943. He served with the RASC and carried out the majority of his active service in the Second World War in Italy. When training to become an officer, he said the most gruelling part of the course was learning to become a motorbike dispatch rider, during which he had a number of painful spills in the wilds of Northumberland. His army years may often have been fraught with danger, but the daily uncertainty which prevailed made them the most exciting time of his life. His most dangerous moment came at Bari in the south-east of Italy, where he was lucky to escape with his life after a massive explosion. An American liberty ship carrying ammunition blew up in Bari harbour on 4 January 1944, killing more than two thousand Allied soldiers and sailors and Italian civilians. Many victims were blown into the sea, and about a thousand families were left homeless. A colleague who was with Captain Stentiford caught the full blast and was killed instantly, but mercifully Captain Stentiford, although injured and suffering deafness for some months, recovered to continue his duties. On his return home at the end of the war he worked at Lloyds Bank, Seaton, where he became assistant bank manager.

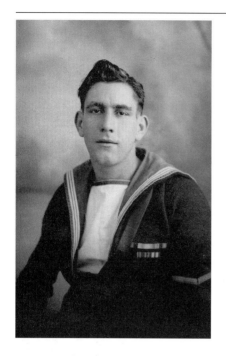

AB D/JX 164062 Roy Lawrence, born in Exmouth in 1924, joined the Royal Navy in 1939 when he was only 15½ years old. In August 1940 Roy joined HMS *Kenya*, a ship that in 1941 took part in the Bismarck hunt. In 1943 he left the *Kenya* to serve on AMC *Canton*, and later he served on HM ships *Snipe, Padstow Bay* and *Illustrious*.

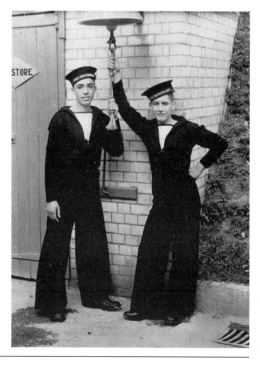

Peter Anstey (left) with Roy Lawrence. Born in Budleigh Salterton, Peter joined the Royal Navy in 1939, at the same time as his friend Roy, and was killed in action when HMS *Repulse* was sunk by the Japanese. He was only seventeen when he died.

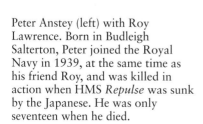

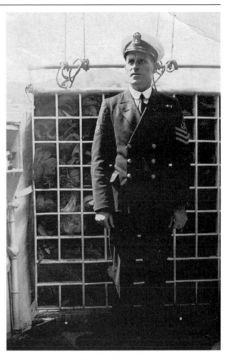

Charles Edward Underwood was born in Midhurst but came to live in Beer after his marriage to local girl Anna Restorick. He had a distinguished career in the Royal Navy, retiring after twenty-nine years' service with the rank of Chief Yeoman of Signals. He saw much active service in the Second World War, taking part in many of the heavy naval engagements in the Mediterranean, particularly at Crete and Malta. He also served as Chief Yeoman of Signals to a Naval Beach Signals Group in the D-Day landings in Normandy. He died on 22 June 1969 at the age of 68.

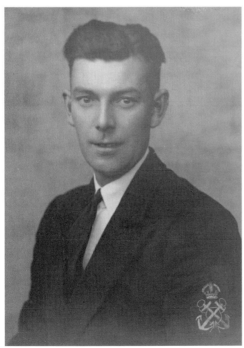

Edward Robert Orley was born in Beer and joined the Royal Navy in 1943 (his enlistment was deferred owing to his being employed by the Admiralty at Bath). He served on HMS *Ausonia*, a depot repair ship, for two years. Most of his time was spent in Trincomalee, Ceylon, but he also visited other Indian ports. His rank was Petty Officer Shipwright and because of his previous boat-building experience he repaired the clinker-built boats from ships returning from the battles in the Burma area. In 1995 Edward Orley was the oldest Beer-born man living in the village at 85 years.

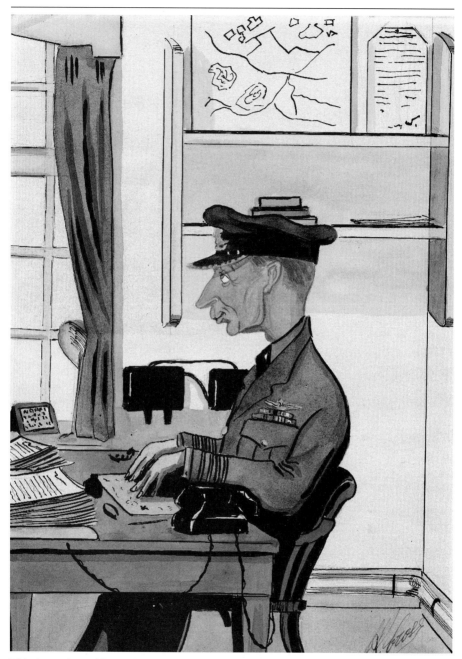

This Second World War cartoon depicts Group Captain Francis Sturgiss RAF who lived in Colyford. The senior officer at Labuan, Borneo, in July 1945, Sturgiss took the surrender of the Japanese forces on the island. At the ceremony of surrender he was handed the Japanese commander's Samurai sword.

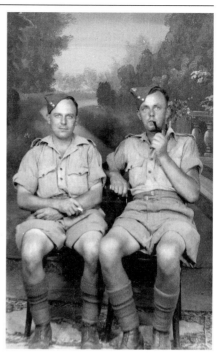

Before the Second World War few people in this country had heard of Tobruk, but during the dark days of 1941 this backwater harbour achieved headline prominence. The Germans under General Rommel advancing on Egypt found Tobruk a hard nut to crack, and the spirited defence of the town by the Australian and British troops won worldwide admiration. Serving with the 8th Army in Egypt and taking part in the siege of Tobruk was George Cyril Restorick who was born in Branscombe in 1911. These photographs show Cyril posing with a colleague in a photographer's studio in Tobruk (Cyril is seated on the right), and standing beside an army lorry in the desert.

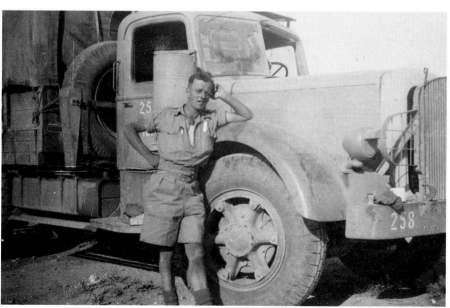

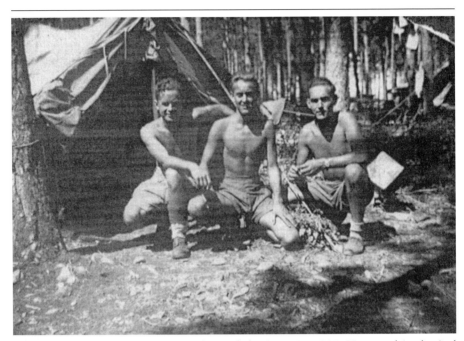

Ron Anning was born in Seaton and joined the Army in 1945. He served in the 2nd Medium Gun Regiment of the Royal Artillery which was based in Italy just after the end of the Second World War. In 1947 Ron saw service in Palestine before his demob in 1948. In the photograph above, Ron (centre) is posing with two colleagues, and (below) he is sitting on a pile of shells for the medium guns; both photographs were taken while they were serving under canvas at Trieste in 1946.

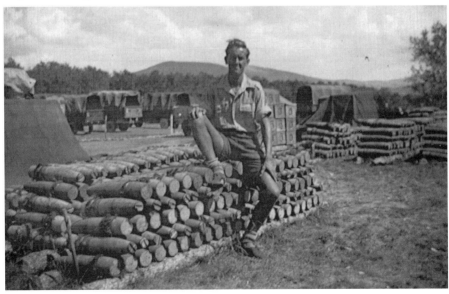

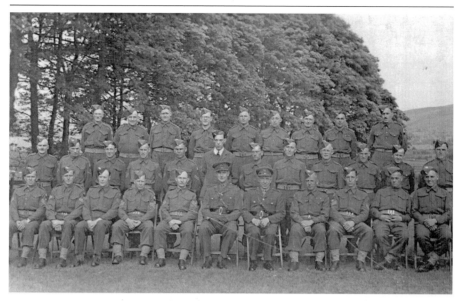

B Company Devonshire Regiment, 1942. Many of these men were from East Devon.

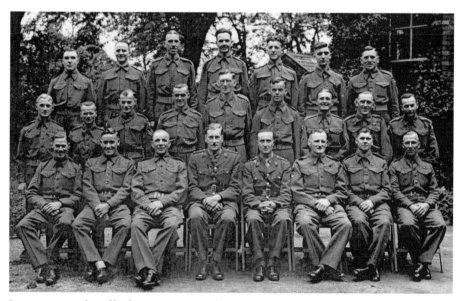

Instructors and staff of D Company 8th Battalion Devonshire Regiment, July 1944. Back row, left to right: Pte D. Burnett, L/Cpls A. Parker, S. Griffin, M. Hempstead, T. Cornwell, Ptes A. Salter, A. Langrish. Middle row: L/Cpl W. Lake, Cpls E. Jones, G. Summerfield, R. Shearman, L/Sgt R. Watts, Cpls R. Wood, S. Brain, W. Bastin, L/Cpl A. Ayres. Front row: L/Sgt E. Gibbons, Sgt N. Holliman, CSM H. Channon, Capt. E.G. Coleman, Lt F.E. Hutchings, COMS A. Dobel, Sgt E. Sloman, Sgt M. Buckland. Many of these men came from East Devon.

Quarter Master Sergeant Nobby Clarke of Branscombe at Cherry Tree Camp, Colchester, 1942. After the war Nobby helped to form the Branscombe Branch of the Royal British Legion, a branch which has won the Cameron Webb Cup for fund-raising many times.

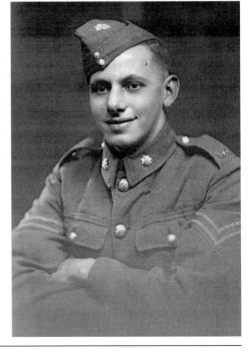

Gerald Abbott, pictured here in 1940, was born in Grapevine Terrace, Branscombe and was known to his many friends as 'Ger'. He was called up in 1939 and served abroad with the 4th Battalion Devonshire Regiment. Later in life he left Branscombe and died in Blackburn in about 1991.

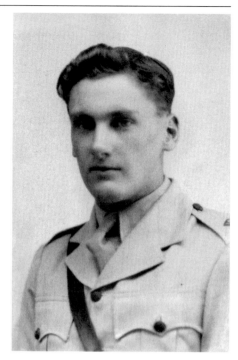

Major Peter G.V. Bellers served in 1940 with the Local Defence Volunteers (later the Home Guard). One of their duties was to patrol Seaton cricket ground at night in case German parachutists landed. He was later commissioned into the 1st Gurkha Rifles, and saw action **against** hostile tribesmen on the North-West Frontier, and in Burma from 1943–5. His battalion was part of the 7th Indian Division which inflicted the first defeat on the Japanese at the 'Battle of the Admin Box'; they later fought both at Kohima and the Irrawaddy crossing and played a part in the total defeat of the Japanese in Burma.

Peter Bellers in Home Guard uniform, *c.* 1940.

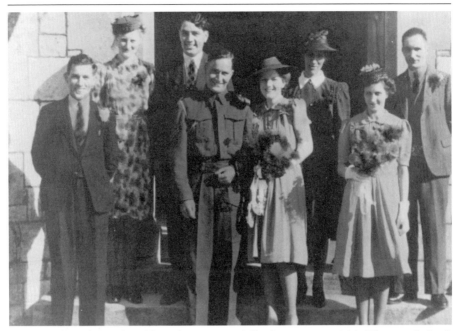

The wedding of Myrtle Jelfs and Sergeant Clifford Dawe, *c.* 1944. The couple both came from Exmouth. Clifford, a sergeant in the Royal Marines, served in North Africa fighting Rommel's Afrika Korps.

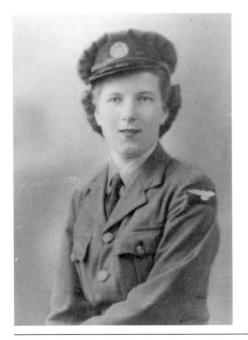

Myrtle Jelfs in WAAF uniform, *c.* 1944. Myrtle was born in Withycombe Road, Exmouth, and served on barrage balloon defences during the Second World War. The work was arduous and included operating the winches and driving trailers. Myrtle married Clifford during the war and died in 1973 aged forty-eight.

Bill Green was born at Seaton in 1929 and during his National Service saw duty in Palestine with the Life Guards in 1947–8.

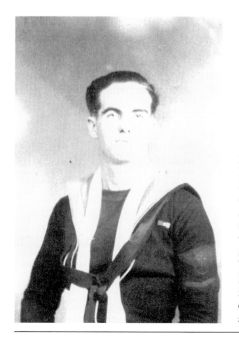

Bill's brother, Jack Green, 1943. Jack was born in Seaton in 1923 and joined the Royal Navy at the outbreak of war aged only sixteen. In 1942 he served on the Arctic convoys taking supplies to Russia around the North Cape and through Arctic waters to Murmansk. These convoys were attacked by marauding aircraft and U-Boats, their crews suffering incredible hardships, including frostbite. Jack was invalided out of the Navy because of his experiences; he never regained full health and died at the age of forty-seven.

Harry Good from Seaton in his
RAF uniform.

Harry Good enjoying a short leave from
the RAF on holiday with his wife in
Weston-super-Mare, August 1940.

Mr G. Sweetland (above) and Mr
E. Davey (below) were both
Express Dairy drivers who served
with the RAF in the Second World
War.

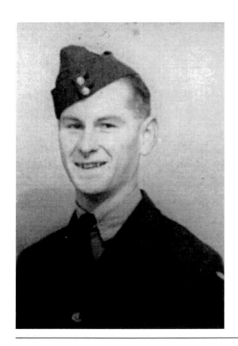

Des Garrett, pictured left in Home Guard uniform and below in Royal Navy uniform, had a varied career during the Second World War. He joined the Home Guard at the age of seventeen and later transferred to the Royal Artillery where he trained on the 6-inch naval guns mounted on the cliffs above Seaton's West Walk. He later joined the Royal Navy, serving on the aircraft carrier HMS *Furious* with the Home Fleet at Scapa Flow and then transferring to HMS *Milford* at Portland. Des then retrained as a transport driver for the East Indies and was in the landing party at Port Dickson, Malaya. Father of the present-day Seaton Town Council, he was one of the town's most popular personalities.

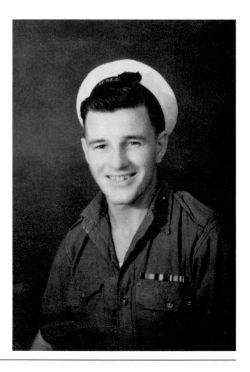

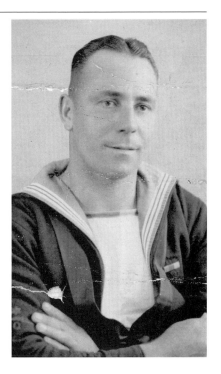

Raymond Driver, *c*. 1941. He was another of those native fishermen of Beer who always served their country so well during times of war in the Royal Navy. Called up in August 1939 he sailed to Bombay in an armed merchant ship to join HMS *Hector*, which was patrolling the Indian and Pacific oceans, and visited India, Ceylon, the Fiji Islands, New Zealand and Australia. He left HMS *Hector* in 1943 and returned home via Durban and Capetown to join HMS *Bradford* on Atlantic convoy escorts. Shortly after his departure HMS *Hector* was attacked and sunk by Japanese aircraft.

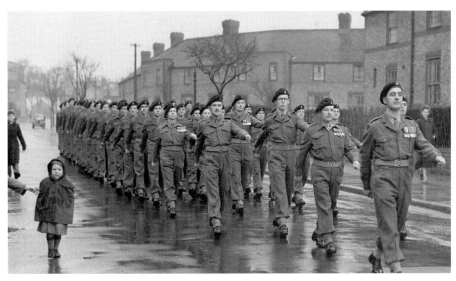

Marching on the left in the front rank is Captain Roy Chapple, Royal Artillery (TA), who did his National Service and then served with the Territorials after the war. He is pictured here with 312 Heavy Anti-Aircraft Regiment in Cheltenham.

Jack Morgan of Seaton (centre) and two colleagues photographed at a reunion in Holland with the 45th Marine Commandos in 1989.

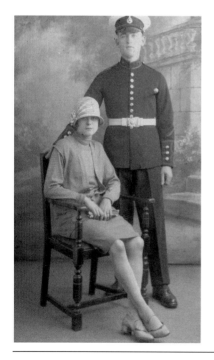

Thomas John Morgan ('Jack') was born in Salcombe Regis and came to Axmouth as a baby; he is pictured here in 1931 with his wife Florence. During the Second World War he served with 45 Royal Marine Commandos and saw action on D-Day, and fought in France, Holland and Belgium. He left the Royal Marines in 1946 with the rank of Lieutenant after twenty-two years' service.

Many Express Dairy staff served in the Armed Forces during the Second World War. Two were killed serving with the RAF and two more had been prisoners of war. On their return from the services, however, some could not settle back in their old jobs and found other work; most, though, came back to their old jobs. Mr R.R. Berry, pictured here, returned from the RAF and took over the Milk Office.

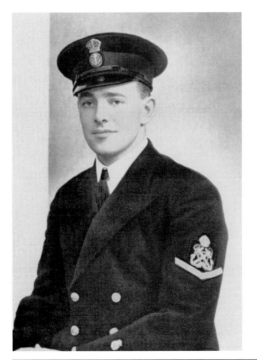

Petty Officer David Chapple, of the Patrol Service RNB, was lost in HMS *Birdlip* off Takuradi in 1944. David was another Beer fisherman who answered his country's call.

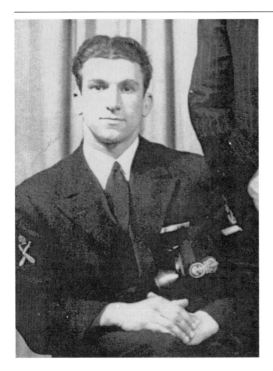

Petty Officer Bob 'Taffy' Pugsley, c. 1944. 'Taffy' joined the Royal Navy in 1939 and served on HM Destroyer *Watchman* from 1940 to 1945, seeing service in the Mediterranean and Atlantic, and on the East Coast convoys. He was involved in the Battle of the Atlantic from the beginning to the end. From 1945 until he left the Navy 'Taffy' was a PT Instructor at HMS *Ariel* Training Camp. He came to East Devon in 1962 as entertainments manager at Warners holiday camp in Seaton and became popular with thousands of campers until his retirement in 1982.

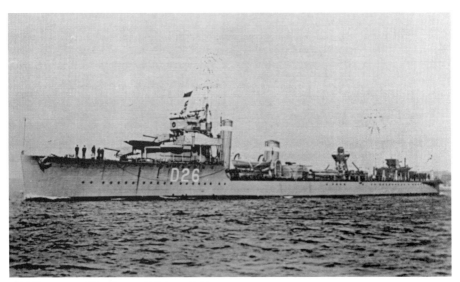

HM Destroyer *Watchman*, D26, c. 1943.

East Devon men in Burma, *c.* 1945. Left to right: Jack Taylor (Seaton), Arthur Board (Colyford), George Bastone (Beer), M. Jones (Seaton). George Bastone joined the Territorials in 1936 and was called up for war service in August 1939. He embarked for India in 1942 and saw service in Ceylon and Burma. He was with the 1st Battalion Devonshire Regiment as they fought their way from Kohima to the south of Mandalay. After the Japanese surrender he went back to India, returning home in 1946. He was Mentioned in Despatches in 1946.

The skill and endurance of the British tank crews in the Second World War are well documented. Originally a British invention and first used in the First World War, tanks played an important role during the Second World War and proved to be a match for the German Panzer Division. Ken Gould, photographed cleaning his equipment in Holland in 1944, was born in Dalwood in 1924. He joined the Army in 1942, serving in the Tank Corps as a mechanic and driver. Ken landed with his tank in Normandy on D-Day plus two, and was engaged in action throughout France, Belgium and Holland, finishing up in Germany where he took part in the victory parade in Berlin.

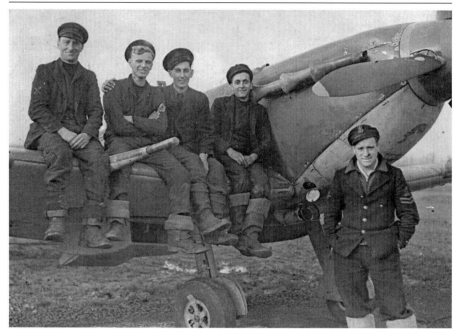

Petty Officer Les Boalch, third from left, sitting on the wing of a Seafire in 1945. This plane had flown in from the aircraft carrier HMS *Furious* for a major overhaul and the fitting of a new engine. At this time Les was stationed at Henstridge in Somerset. The other men in the photograph were serving on HMS *Furious*.

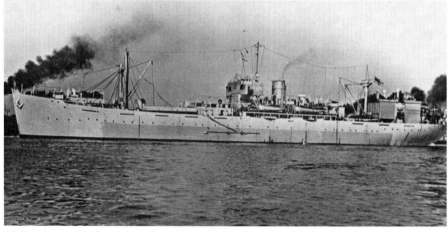

HMS *Moray Firth*, 1945. The *Moray Firth*, built in South Shields, was a support workshop boat for aircraft carriers. The barge on the deck was used to ferry aircraft engines from the carriers to this floating workshop where repair and overhauls could be carried out. The *Moray Firth* carried a crew of only twenty seamen; Petty Officer Les Boalch from Beer was in charge of the test bench on the poop and was often called to assist in navigation.

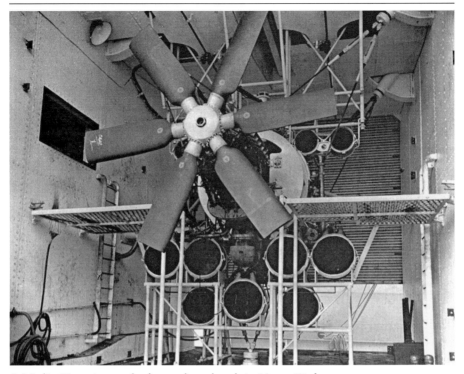

A Merlin 32 engine on the forward test bench in *Moray Firth*.

The test bench control room on HMS *Moray Firth*.

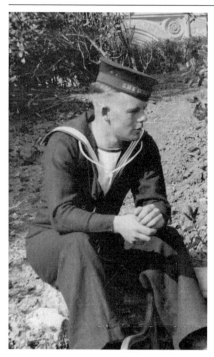

Rupert Aplin was another native of Beer who served with the Royal Navy during the Second World War.

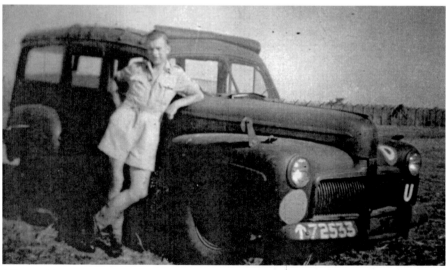

Allan E. Trott, at 309 MU, RAF Palam near New Delhi, India, 1946. Born at Seaton in October 1925, Allan was in the Colyton Grammar School ATC before joining the RAF on 8 November 1943. At that time all ATC boys who went into the RAF had a service number prefixed with 30. He commenced his service life as a wireless operator/air gunner and remustered six months later as a flight engineer. He remustered again as a motor mechanic fitter and went to India in 1945. He was demobbed on 1 February 1948.

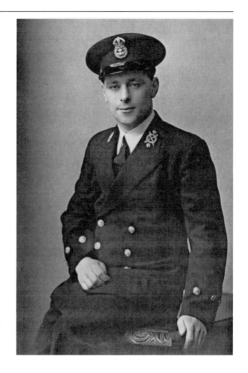

Chief Petty Officer Arthur James Chapple HSD, RNR, *c.* 1943. Born in 1915, Arthur Chapple was the third son of a Beer fisherman, and like all boys of that village was born for the sea. He left school to become a fisherman on the Arctic trawler fleet. He mobilized in 1939 and served on the Western Ocean convoys and Canadian new constructions. He transferred to general service in 1946, and served in the West Indies, the South Atlantic, Antarctica, the Mediterranean and the Far East. He retired from the Navy in 1961.

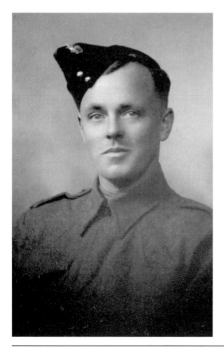

Private George Cyril Restorick, *c.* 1940. He was born in Branscombe in 1911. During the Second World War he served with the 8th Army in Africa and took part in the siege of Tobruk during 1941. He died in 1987.

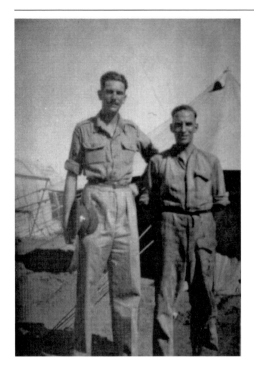

Next door neighbours CFN Reg Jones and Sergeant Eric Munday from 2 and 3 Highwell Road, Seaton, photographed when they met in Palestine in 1945.

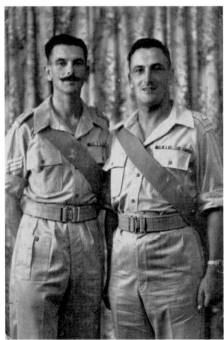

Local boys from Seaton, Sgt Eric Munday (left) and Sgt Bill Baker pictured when they were serving with the 1st Grenadier Guards in Palestine and Libya, *c*. 1946.

Jim Mutter, *c.* 1943. Jim served with the RAF during the Second World War and returned to Seaton after the war to continue working in the family fishmongers business.

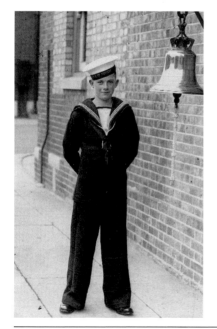

Boy seaman John Wells from Seaton joined the Navy in 1938. On 17 September 1939 he was serving on HMS *Courageous* when she was torpedoed and sunk by U–29 west of Ireland, with a loss of 518 lives. John managed to escape by climbing through a porthole. He died in 1995 and his ashes were buried at sea.

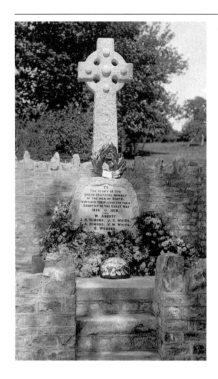

The Wayside cross erected in Shute in memory of the six men from the village who fell in the First World War.

Colyton man John Trivett joined the Army on 3 March 1939, and served in the Royal Engineers. He saw service with the 1st Army in North Africa and landed in Europe on D-Day plus two. John left the Army after ten years' service in 1949 with the rank of staff sergeant.

Seaman Reginald Thomas ('Rex') Good RNRP/X7734 of Cliff Hotel, Seaton, who died of wounds received in action on 11 April 1941. Rex was serving on SS *Draco* when she was attacked by dive-bombers at Tobruk on 11 April 1941. Mortally wounded with severe leg wounds, he was transferred from the gun platform of his sinking ship to a lifeboat and then quickly conveyed to Tobruk hospital where he died at midnight on 11 April. He was buried at Tobruk War Cemetery (grave no. 64) and was posthumously awarded the George Medal for devotion to duty.

Sergeant Flight Engineer Thomas Hill Clapp, pictured here with his sister Ellen, was the son of Annie and Sam Clapp. Tom was born in Seaton on 2 January 1924 and was educated at Sir Walter Trevelyan's School. He was a member of the Colyton Grammar School ATC and joined the RAF at the age of eighteen. He flew in Wellington bombers and was killed on active service over Lincolnshire on 3 October 1943. He was only nineteen and his death left a void in the family that was never filled. Ellen, his sister, joined the ATS and after the war played an important part in the Seaton Royal British Legion.

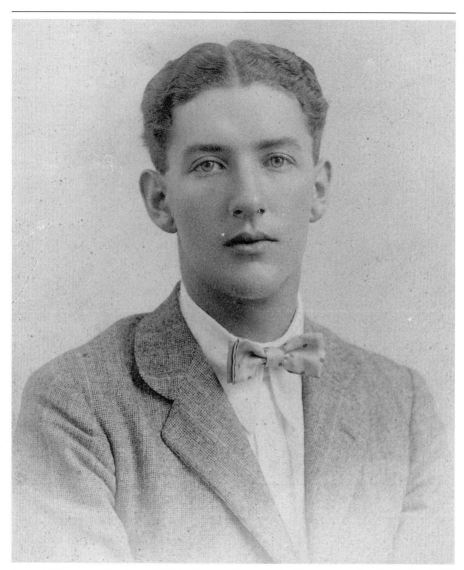

Second Lieutenant Reginald Wilkie Gosney, the son of a Seaton chemist, 1913. Reginald found himself in France shortly after the outbreak of the First World War. He was on the Indian Army Reserve of Officers attached to the 76th Punjabis and in 1915 was transferred to Mesopotamia where he took part in the capture of Kut and the ill-advised advance to Baghdad. After the capture of Kut the British forces advanced to attack the Turkish position at Ctesiphon. The British rifle strength was 13,000, while the Turks numbered more than 18,000; after the battle on 22 November 1915 the British retreated with more than 4,500 casualties. The dead were left to be buried by the Turks with no regard to identification. Lt Gosney, who was Mentioned in Dispatches, was killed in the battle of 22 November and his name is inscribed on the BASRA Memorial in Iraq to those who have no known grave.

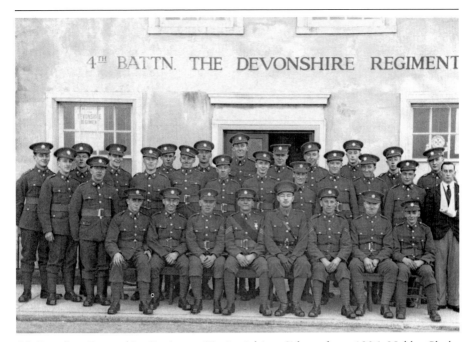

4th Battalion Devonshire Regiment (Territorials) at Sidmouth, *c.* 1936. Nobby Clarke from Branscombe is seated on the far right.

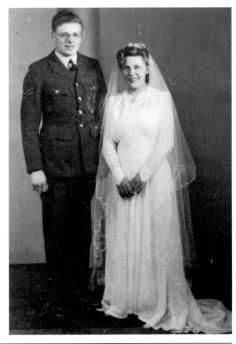

Bill and Peggy Turton on their wedding day. Born in London in 1920, Bill joined the RAF in 1940 and served for three years as an electrician in Fighter Command before transferring to Bomber and Transport Commands. During his service he worked on Spitfires and on the Halifax bombers which flew with the Thousand-Bomber Raids over Germany. Peggy did war service in the Women's Land Army. Bill retired to Axmouth in 1985 where he became much involved in the activities of the Axe Valley Heritage Association.

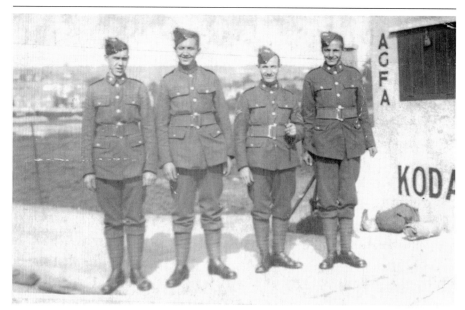

A few days after the outbreak of the Second World War the campers at Warner Holiday Camp in Seaton had packed up and left the site ready for it to be used as an internment camp. Barbed wire fencing was erected around the camp and these Army lads from Branscombe were on guard duty after the internees had arrived. Left to right: George Grattan, Norman Somers, Nobby Clarke, Ger Abbott.

Soldier Release Book, dated 2 December 1945, belonging to Quarter Master Sergeant Nobby Clarke, service no. 5618527, of Branscombe.

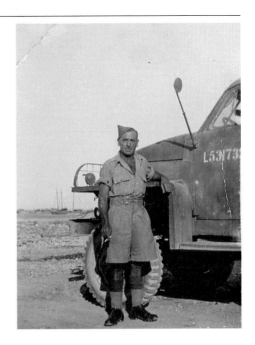

Harry Small from Sidmouth, who was killed in Italy during the last months of the Second World War.

Jim Gosling, 1942. Jim joined the Devonshire Regiment in 1940 but because of an injured leg was later transferred to the Pioneer Corps. A part of his wartime service was spent at Heathfield Camp, Honiton, where he was one of only three British soldiers in a camp of over a thousand American servicemen.

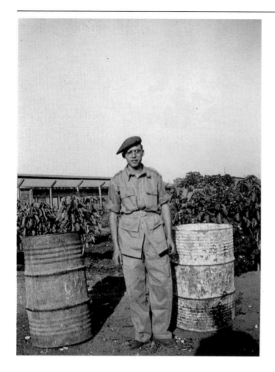

Tony Barr in Egypt, *c*. 1945. He was born in Seaton on 14 January 1926 and saw service with the Royal Army Medical Corps.

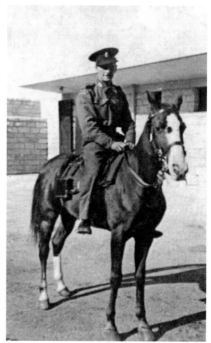

E. Davey, a pre-war Express Dairy driver at Seaton Junction, photographed on horseback after his transfer from the RAF to the Army, *c*. 1944.

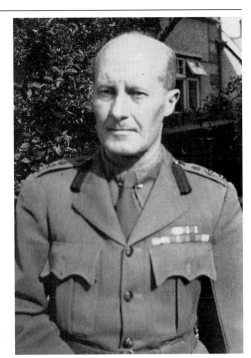

Brigadier E.V.R. Bellers commanded 2nd/1st Gurkha Rifles on the North-West Frontier, and the Peshawar Brigade on the Afganistan Frontier. Later he organized the back-up for the British and Indian Forces fighting the Japanese in Burma. He did not see his family in Seaton for the duration of the war.

Seaman Leslie Boalch, 1942. Les Boalch was born in Beer in 1923 and joined the Royal Navy in 1942, serving first on the training base at HMS *Raleigh* at Torpoint. He later transferred to the Fleet Air Arm, where he reached the rank of Petty Officer.

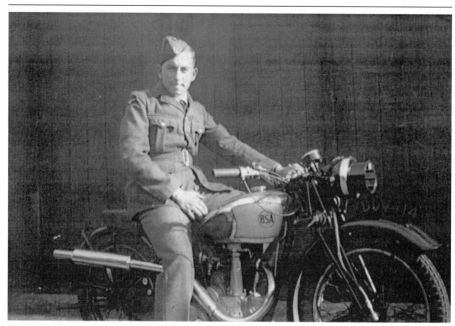

Gerald Oborn from Beer home on his first fourteen-day leave from the RAF, August 1941. The motorcycle was a 250cc Sports BSA.

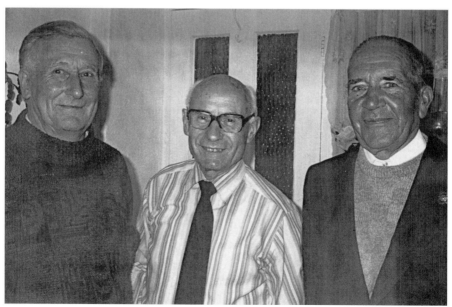

These old soldiers from Branscombe met in 1989 to talk about their wartime experiences. Left to right: Oscar Pike, Nobby Clarke, Bert Warren.

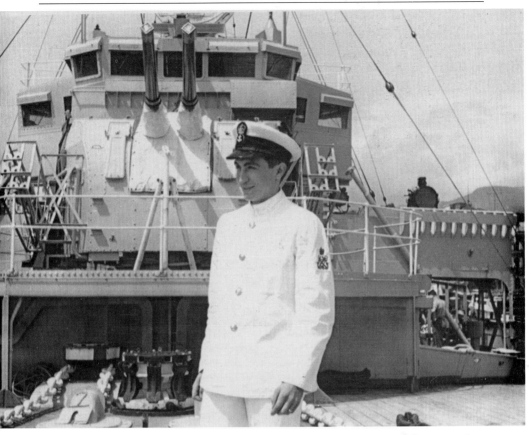

Petty Officer Ian Thomas, photographed on HMS *Protector* in 1965. He later served on HMS *Glamorgan* during the Falklands War. Ian was born in Swindon but after his naval career settled in Seaton, where he runs a restaurant.

Men from the West Country are still fighting to maintain liberty and democracy in distant lands and acting as peacekeepers where required. Many servicemen from East Devon served in the Falklands War and these two photographs show the damage to HMS *Glamorgan* after she was hit by a shore-launched Exocet missile on 12 June 1982. Petty Officer Ian Thomas from Seaton was serving on the *Glamorgan* at the time of this attack which resulted in the deaths of seventeen of her crew. The *Glamorgan* was the only British ship to survive an Exocet missile strike. (*Above*) the hole in the flight deck, and (*below*) the hangar flight deck with the door blown away.

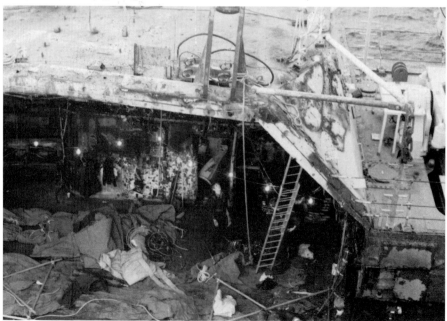

Section Four

THEY ALSO SERVED

The voluntary services were quickly organized for the national emergency. An appeal broadcast in May 1940 for volunteers for the Local Defence Volunteers had hardly ended before hundreds of East Devonians were queueing at Post Offices to be registered. Later the LDV was reorganized and renamed the Home Guard. The men soon went into rigorous training, with drills and parades, midnight exercises over the cliffs, guard and picket duties in lonely spots, all making ready to be called out for their primary purpose, defence against invasion.

The National Fire Service, Rescue Squads, Police and Special Constabulary were also turning out on every alert. The firemen in particular were not confined to local incidents, being called away to render help in Exeter and Plymouth when those cities were blitzed.

The Observer Corps was formed and look-out towers built along the coast. For five years they kept continuous watch, day and night, reporting all aircraft movements. Raiders passed over East Devon to attack places as remote as Liverpool and Belfast, and in these cases the alert would last all night, until the planes returned on their way back to Northern Europe. On one occasion the Exmouth observer post on Orcombe Point was machine-gunned by a Dornier and showered with a stick of incendiary bombs, but without injury to those on duty.

The Air Raid Precautions Committee was also busy. In Exmouth it appealed for six hundred volunteers and soon afterwards had distributed 27,000 gas masks, and twenty-two air raid shelters were erected with accommodation for over a thousand people. The Library in Exeter Road was requisitioned for the ARP Headquarters and Control Centre, and altogether some 1,300 alerts and actual incidents were dealt with by the mixed staff on duty; they ranged from elderly men to women telephonists and young messenger boys.

Many other organizations, including the Women's Voluntary Service, YMCA, Salvation Army, and the Voluntary Aid Detachment nurses, played their part magnificently throughout the war.

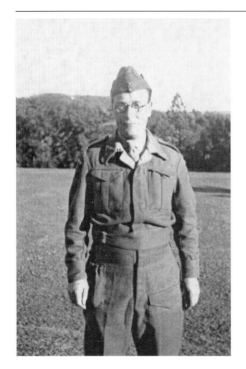

Lieutenant E.R. Clarke was the Officer in Charge of the Shute and Wilmington Home Guard, whose members included Express Dairy staff at Seaton Junction.

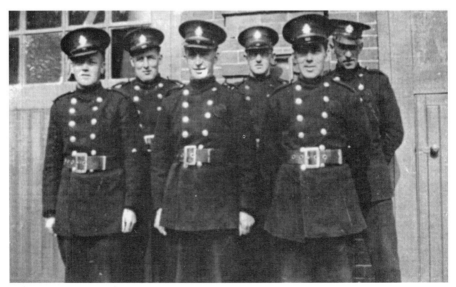

Members of the local National Fire Service who helped out at the Express Dairies, Seaton Junction, c. 1942. Staff shortages had become a real problem as more and more people were called up.

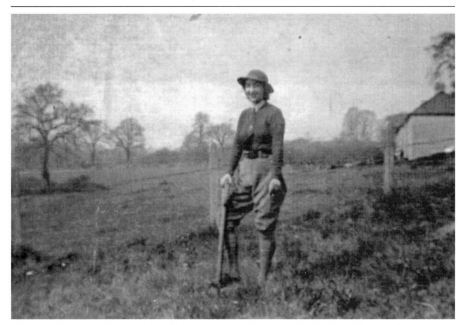

Miss R. Hewes, a Women's Land Army girl at Shute, *c.* 1942. The Women's Land Army played a most important part during the Second World War with many women and girls from different walks of life soon becoming proficient in their new duties.

In 1942 Express Dairies at Seaton junction opened a canteen to help staff with their food problems. The Government at this time allowed extra rations for canteens to help the workers. The food was cooked in the girls' rest room and the staff took it out to eat wherever they could find somewhere to sit down. Pictured here is Mrs I. Cox, the lady in charge. She was also the local Billeting Officer.

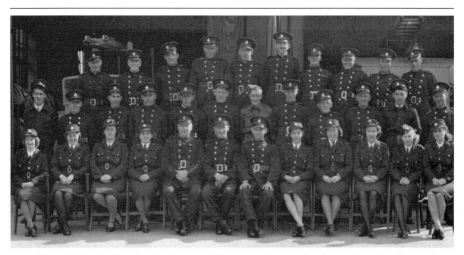

Members of the National Fire Service, Seaton, *c.* 1943. At the outbreak of war there were more than 1,400 local fire authorities in England and Wales. These were consolidated into a single National Fire Service, giving the advantages of greater mobility and a universal standard of training and equipment. These firemen played a heroic part in the defence of Exeter and Plymouth during enemy bombing.

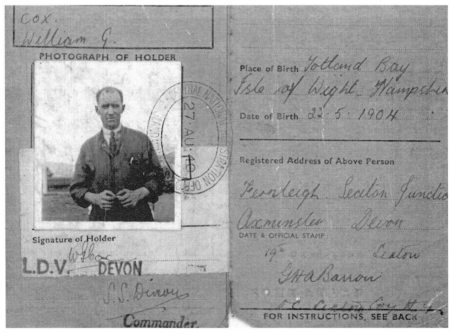

To save petrol the Milk Marketing Board zoned all collection areas, and the Express Dairy staff at Seaton Junction had to get to work on foot, on bicycles or by train. Seaton Junction was in a 'Defence Area' and all transport staff were issued with special identity cards to allow them to travel in the area. This one was issued to William G. Cox.

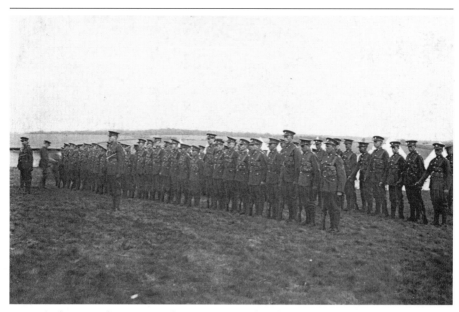

Between the wars the Territorial Regiments used to hold camps at important places in the countryside, enlivening rural England and adding to the pleasures of the soldiers' lives. In the summer of 1939, just before the outbreak of the Second World War, the 4th Battalion Devonshire Regiment (Territorials) held their camp at Corfe. Young men from Seaton, Branscombe and Sidmouth attended this camp and for them it was a chance to have a break from everyday life, together with local friends.

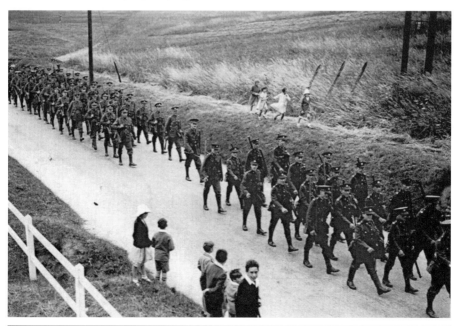

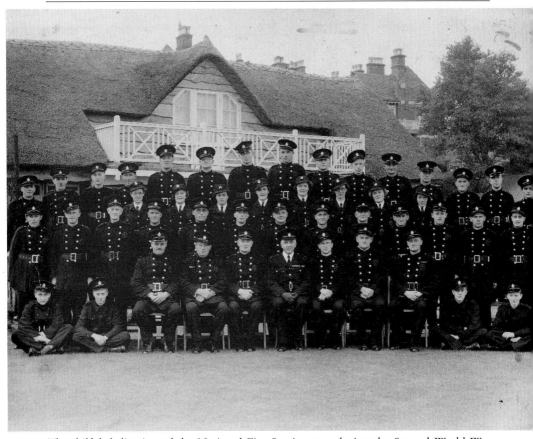

The skilful dedication of the National Fire Service men during the Second World War must never be forgotten. Many heroic exploits were carried out by them during the air raids and they performed deeds of bravery comparable with their comrades in the armed forces. These men and women from the Sidmouth National Fire Service, pictured here in about 1944, played a heroic part in the defence of Exeter and Plymouth against enemy bombing. Mr Ernest Charles Beer is seventh from the end of the second row. He became chairman of Sidmouth Urban District Council in 1961.

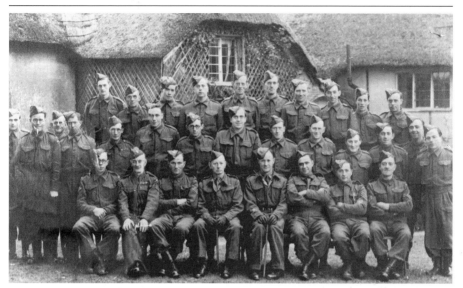

The plan to raise Local Defence Volunteers in 1940 met with an immediate response all over the country. The name was soon changed to the Home Guard (although they were known affectionately as Dad's Army). By the end of 1940 the Home Guard numbered 1½ million men and during the preparations for D-Day in 1944 they took over most of the security duties on the home front. These men from Seaton and Colyton played an important part in the Second World War and after their final muster in 1945 much appreciation was felt by all for the voluntary work they had done during the difficult days of the war.

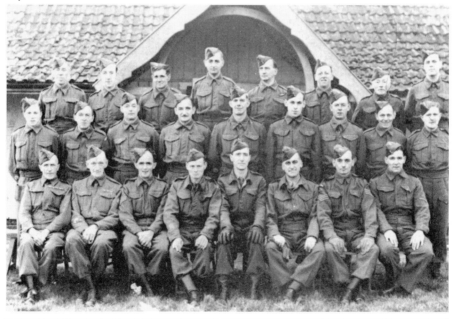

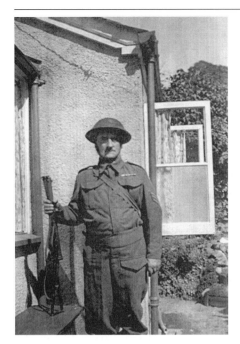

Local stalwart Mr W.L. Oborn of Beer, armed and in full Home Guard uniform, ready to combat any invasion threat.

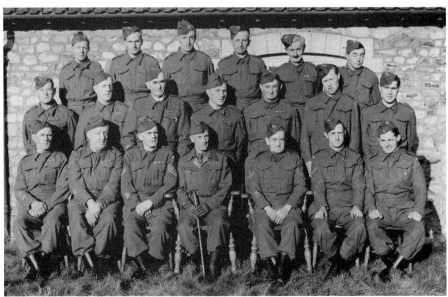

Axmouth Home Guard, *c.* 1942. Back row, left to right: Jeff Puddicombe, Gordon Hunt, Ray Hunt, Leslie Hunt, Mr Mann Sr, Mr Mann Jr. Middle row: Herbie Clements, Jack Good, Ted Snell, Jim Cross, Jim Board, Ken Morgan, Mr Mann. Front row: Frank Snell, Harry Newbery, Len Weekes, Revd Mr Swift, Howie Owen, Ken Webber, Victor Worden.

Mr C. Dawe, Chairman of the Gibraltar Club in Chapel Street, Exmouth, at a presentation to the oldest Royal Marine member. Also present that day and shown here was the youngest Marine recruit from Lympstone.

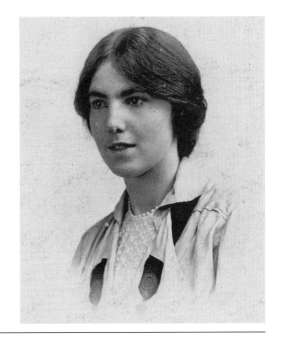

Muriel Head, only daughter of William Henry Head (1878–1958), in 1918. Her father was much involved in the local community and became Seaton's youngest ever town councillor. In his time he was probably the most popular man in the town. Muriel worked in Exeter during the First World War as a member of the Voluntary Aid Detachment (VAD), nursing wounded soldiers. Although the VAD nurses worked voluntarily, they were much involved in the brutal realities of wartime nursing and by the end of the war had proved their usefulness.

Mrs Nancy Bellers of Seaton was awarded the BEM for her service in the WRVS, which she joined at its formation in 1939. Previously she was awarded the Kaisar-i-Hind Medal in India after setting up four welfare centres for Indian Army families, and a family wing at the Medical Hospital at Delhi Cantonments. She was leader of the Seaton Darby and Joan Club, and President of the Seaton Royal British Legion women's section. She was also the Seaton and District Girl Guide Commissioner, and founded the local Trefoil Guild. She also served as a member of the House Committee of Marlpits Hospital, and was Chairman of Colyton Day Centre.

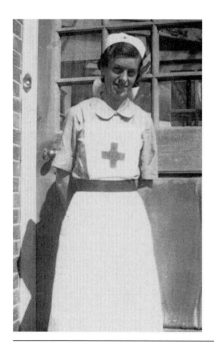

Eileen ('Lan') Mutter of Seaton in her VAD nursing uniform. She worked full-time with the VAD from 1943 to 1947.

National Servicemen Ted Gosling and Harold Legg 'square-bashing' with the RAF at West Kirby, August 1948.

A member of the Home Guard leaving for duty at Shute, *c.* 1943.

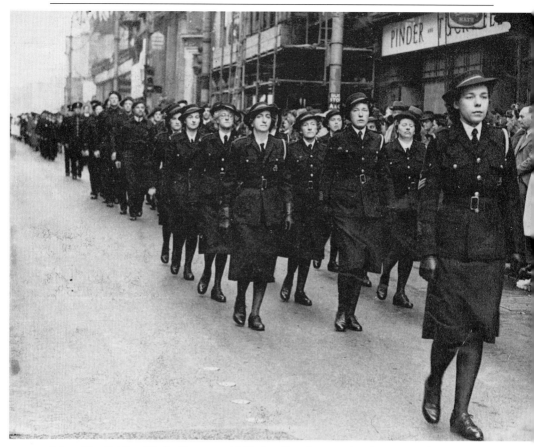

Salute The Soldier Week, Exeter, *c.* 1943. Leading the parade of Exeter Policewomen is Sgt Gladys Yelland. After the Second World War Gladys went to live in Beer and married local fisherman Rupert Aplin.

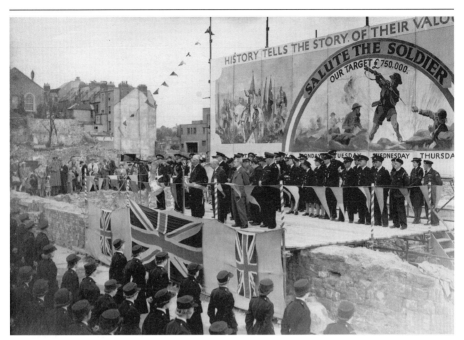

Salute the Soldier Week, Exeter, *c*. 1943. Exeter's wartime mayor, Mr R. Glave Saunders is taking the salute. Standing at the rear, second right, is Gladys Yelland, who at this time was a supervisor in the Police control centre (see opposite). Note the bomb-damaged Bedford Circus in the background.

In the tense days of 1939 volunteers in East Devon queued to join organizations such as the Auxiliary Territorial Service. Other needs included air-raid wardens, ambulance drivers and Coastguard watchers.

Tom Newton of Seaton at Buckingham Palace with his wife Rene after receiving the BEM. Having served with distinction in the First World War, Tom joined the Home Guard in the Second World War. He was awarded the BEM for securing and rendering safe a mine in the River Axe.

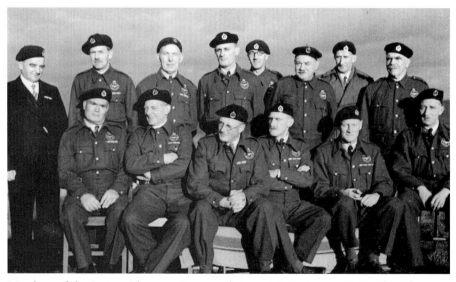

Members of the Seaton Observer Corps at their post in Seaton, *c*. 1943. The Observers rendered valuable service during the Second World War. They were posted throughout the country and kept watch night and day for any sight or sound of enemy aircraft. Britain's defences would immediately swing into action if these devoted watchers in their far-flung outposts spotted anything untoward. Observers pictured here include Walt Lovering, Bill White and Archie Richards.

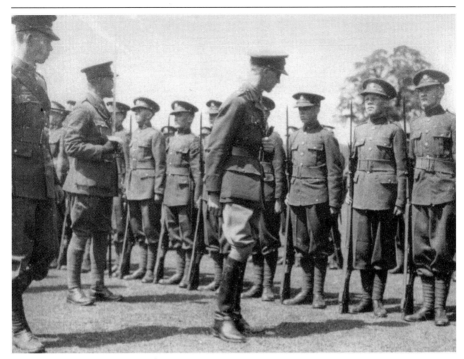

Allhallows School OTC on parade for an inspection by General D.E. Wyatt, Honiton, 1935. Terry Glanvill, then aged thirteen, is in front of the general.

These Home Guard men, shown here on duty in about 1943, were all Express Dairy staff at Seaton Junction (see page 26).

AROUND THE TOWNS

One of the first incidents of the Second World War occurred on Sunday, 17 September 1939, just two weeks after war had been declared on Germany, when the aircraft carrier HMS *Courageous* was sunk by a German U-Boat (U29) in the Atlantic to the west of Ireland. A total of 519 of her crew perished, many of them Devon men, including Capt. W.T. Makeig-Jones, whose mother and sister lived at 'Carisboro', Fremington Road, Seaton. This disaster was felt very deeply by the local people of East Devon, to whom the war was very real and not 'phoney'.

Warners Holiday Camp at Seaton was requisitioned and reopened in October 1939 as an internment camp for classified aliens. The camp consisted largely of wooden huts situated close to the seafront. These huts were subject to frequent flooding so Army huts were soon built on the opposite side of Station Road, and a high barbed wire fence erected around the camp complex. Wooden observation towers were also erected at all four corners, manned by armed guards. The camp had a curious mixture of aliens, including Jewish refugees, Germans who had fled from Nazi Germany, other German nationals and also known Nazis. Forced to live together, they all agreed to an unofficial truce, although fighting did sometimes break out. Later on, when the invasion of England was expected, the British Government decided on the mass internment of all alien subjects, including Italians. They also arranged for the deportation of a large number to Canada, and the pre-war luxury liner, the *Andora Star*, sailed from Liverpool with 1,600 internees aboard, some of whom were from the Seaton camp. During the crossing the ship was torpedoed and sunk by a German U-boat in the Atlantic.

In 1940 the RAF came to the area and no. 13 Radar Station was built on Beer Head, with a prominent wooden tower and mast. Early in the war, radar was our secret weapon, and it provided early warning of the approach of

enemy planes. The unit at Beer was the first to make contact with Mr Churchill returning in his plane from his important meeting with President Roosevelt. A subsidiary camp for housing the RAF personnel was built at nearby Weston, the centre of which being where Stoneleigh Leisure Centre stands today.

Beach and coastal defences were erected along the coast. Seaton was guarded by two 6-inch naval guns of no. 402 Coastal Battery. At Sidmouth the Coastal Battery was equipped with one naval gun and one French gun, both of First World War vintage, and a 16-pounder gun. At Exmouth the swing bridge and wooden jetty were immobilized each night. Tank traps, concrete anti-tank defences and pillboxes were erected. The pillbox was a means of static defence against enemy infantry forces. Old cars were dispersed on Honiton Common to prevent enemy aircraft or gliders landing.

In May 1941 Rudolph Hess landed in Scotland, causing considerable national interest; less well known was his connection with East Devon: his father had married his first wife at Exmouth, and on her death she was buried in the local churchyard.

Dunkeswell, 4 miles from Honiton, was the base of the only US Naval Air Station in the United Kingdom. From this elevated East Devon airfield the US Navy flew Liberators on anti-submarine patrols. The continuous vibration caused by the huge aircraft resulted in the tower of Dunkeswell Church becoming unsafe and having to be rebuilt. In that church is a memorial plaque to Joseph Kennedy, elder brother of the late President John Kennedy, who lost his life on one of those patrols.

Four miles to the east of Dunkeswell, near the Somerset border, US Air Force Station 462 was opened at Smeatharpe, close to the small village of that name. The Americans took over the airfield from the RAF and used it as a base for glider training and troop carrying. On the eve of D-Day the men of the 101st Airborne Division flew from here to Normandy in eighty-one 'sky trains'.

RAF Exeter, at Clyst Honiton, became USAAF Station 463 in April 1944, and was also used for glider training. There was a large American presence in East Devon during the months before D-Day, and the 4th Infantry Division troops were stationed at Seaton. More Americans were stationed at Heathfield Camp at Honiton. As a result of the many Americans stationed in the area there were numerous GI brides.

An American Military Field Hospital was established at Millway Rise, Axminster, and another convalescent hospital was built alongside the water tower above Seaton.

During the period from August 1940 to early 1943 East Devon was subject to many air raids. In 1942, during a night attack on Exeter, a German plane was shot down over Beer, one of its engines landing in a field on one side of the village, with the main part of the plane crashing in Bovey Lane. The crew had parachuted to safety, landing on Beer Common where they were quickly picked up by the Home Guard. On another occasion a lone Messerschmitt 109 strafed and machine-gunned Colyton; fragments of the shells are still occasionally found around the houses at Hillhead. Seaton was the target of

hit-and-run German raiders who were attempting to destroy the naval gun on Cliff Field, which was disguised as a small house. Unfortunately another house nearby, at the corner of Seahill and Castle Hill, was hit and demolished, resulting in the death of the Cartwright family who were having lunch at the time. Other bombs fell in Highwell Road and Harepath Road, where Mrs Walton, widow of the church organist, and two evacuee girls were killed. An air-raid shelter was built in front of the Church of the Good Shepherd for the use of the townspeople.

A landing craft was beached at Seaton after returning from the D-Day landings. On 26 February 1943 Exmouth had its last air raid. Eight Focke-Wulf fighter bombers, sneaking in over the town in daylight, killed about twenty-five men and women, and a little girl.

In Sidmouth more than five hundred air-raid alerts were sounded. The town was occasionally machine-gunned from the air and sometimes enemy pilots dropped on Sidmouth bombs that had been intended for Exeter. A coastal defence battery was established in the Connaught Gardens, and Army and RAF contingents were stationed in the town. The grounds of the Knowle Hotel were used as a training area for commandos.

Special War Savings weeks were held at intervals throughout East Devon between 1941 and 1945; these comprised War Weapons Week, Warship Week, Wings for Victory Week, Salute the Soldier Week and Thanksgiving Week. Exmouth raised over four million pounds altogether.

At last, on 8 May 1945, peace in Europe came and two days national holiday were declared. Free entertainments, communal lunches and tea parties were held in the streets. In Britain's time-honoured way of signalling victory since the Armada, massive bonfires were lit on prominent sites and a tremendous feeling of relief spread over the whole of East Devon.

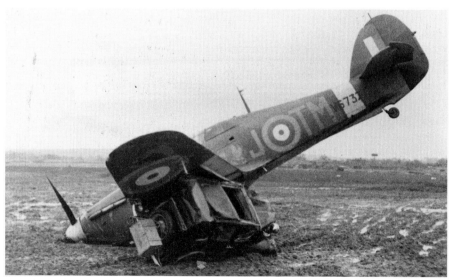

A wartime collision at Exeter Airport between a Hurricane and a car, 1941.

Gun emplacement in Cliff Field, above the West Walk, Seaton, *c.* 1942. Built to resemble a house, it provided camouflage for two 6-inch naval guns which were used for coastal defence. They fired 100-lb shells, and during one early gun practice the noise from the barrage shattered windows in nearby houses.

The Church of St Gregory, Seaton, 1942. This picture is part of the photographic record which was compiled in case the church was destroyed by enemy action.

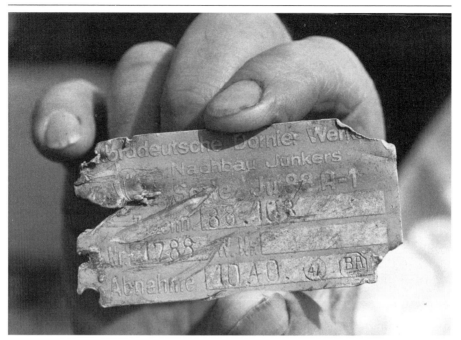

The engine number plate from a Junkers 88 bomber shot down at Longdown in 1942. It was salvaged from the wrecked aircraft by Reg Frampton (below) from Exmouth, shown holding the plate in 1989.

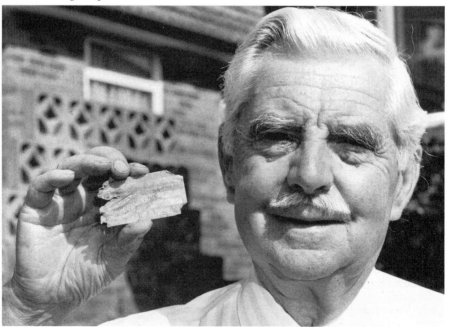

W.L. Oborn, proprietor of Townsend Garage, Beer, posing with the unexploded bomb that was dropped by a German bomber in Paizen Lane, Beer, in May 1944.

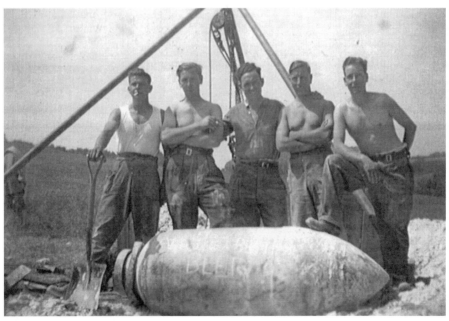

The Bomb Disposal Units of the Royal Engineers had the thankless task of digging out and making safe the many unexploded bombs that fell on England during the Second World War. Pictured here during May 1944, the men of one such unit are working on the unexploded bomb in Paizen Lane, Beer.

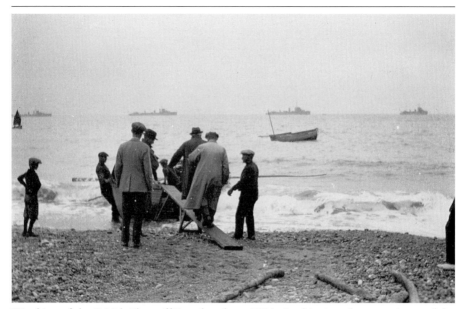

Warships of the British Fleet off Beer beach, *c.* 1921. At this time the sovereignty of the Royal Navy over the seas was far-reaching and absolute, and a paramount condition of our national existence.

Home on leave from the RAF, Gerald Oborn is pictured here with his mother at Townsend Garage, Beer, in 1942. The car was a 1937 Austin 12 which was used as a taxi for the Oborn family garage business. Note the regulation blackout headlamps.

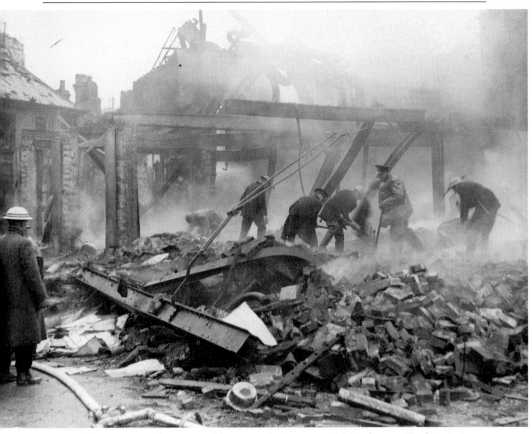

Exmouth experienced its own blitz on 18 January 1941 when an indiscriminate bombing raid was made on the town. This is Chapel Street the morning after the raid, with members of the AFS and ARP examining the rubble.

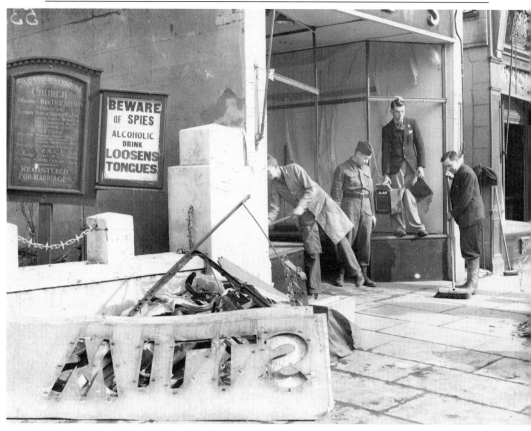

The Parade, Exmouth, was hit by a bomb on 1 March 1941. The premises of Wills and Millicans were destroyed and the Parade Methodist Church (left) was badly damaged.

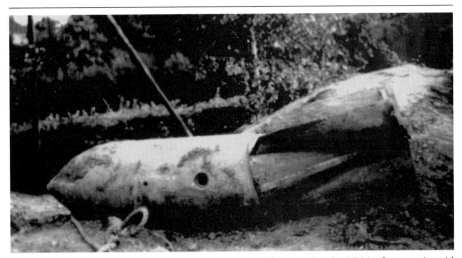

Unexploded bomb at Seaton, 1944. Late one Saturday evening in 1944 after an air raid warning, a German aircraft being chased out to sea jettisoned its load of two 1,000-lb bombs to facilitate its escape. Mrs Irene Fox, standing at her front bedroom window in Westmead, Seaton Down Road, Seaton, thought the loud swish was a plane brushing the tall trees in Florrie Erskine's garden behind Westmead. In fact the two bombs had fallen within feet of each other on either side of the dividing fence at the bottom of the garden. The ARP warden soon arrived and told elderly Miss Cornish and the Fox family that they and other neighbours must evacuate the premises. Mrs Fox's son Ray was away at a Colyton Scout Camp and did not know of the incident until Church Parade the next day when he was greeted by the Revd Mr Cooke with the words, 'Ah, Fox, a bomb fell on your home last night but fortunately didn't go off.' The bomb disposal team spent some days digging down and defusing the bombs.

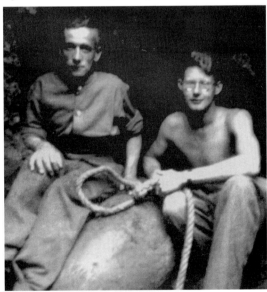

The corporal in charge of the Bomb Disposal Squad (right) and his second-in-command.

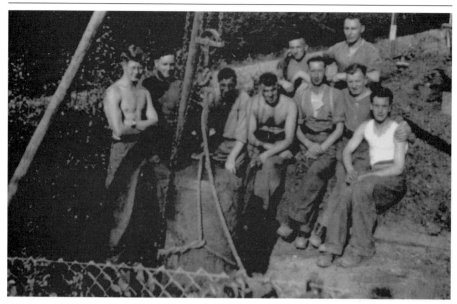

The Bomb Disposal Squad in Mrs Fox's garden, winching the bomb up out of the crater.

Eddie Fox, Managing Director of Mitchell Bros Builders, showing part of the bomb mechanism, now harmless, to his wife Rene and Archie Richards (centre).

Section Six

EVERYDAY LIFE DURING THE WAR

On 1 September, two days before war was declared, the first evacuation scheme from London and other big cities began to operate, and within a few days the first contingent arrived at Exmouth railway station. The organization was splendid and scores of locals lined up to take the unfortunate women and children off to their new homes. Each week saw a new influx until the position became desperate; willing householders had every room occupied, but stronger methods had to be used on those not so willing. In October 1940 150 evacuees bombed out from the East End of London arrived at twelve hour's notice, with 400 more expected the next day. In Sidmouth almost four thousand evacuees were accepted, mostly from London, in addition to many others staying privately in guest houses and the unrequisitioned parts of hotels. The members of the voluntary organizations achieved wonders and did wonderful work right through the war.

Strict food rationing was introduced and people were encouraged to 'dig for victory' by growing their own food in their gardens and allotments. Blackout material was in great demand to cover the windows at night, and strict control was exercised on householders by the ARP and Special Constabulary. The nation was provided with Identity Cards and petrol was strictly rationed through coupons. Vehicles could only obtain their petrol from a few designated garages throughout the area.

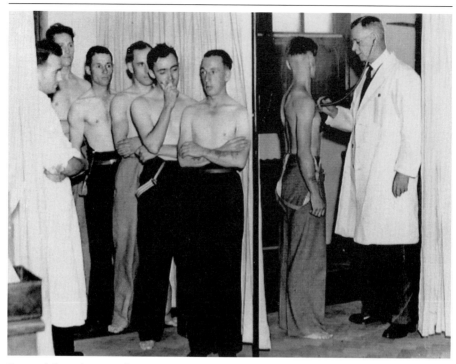

Some of the volunteers from East Devon waiting for their medical examinations, 1939.

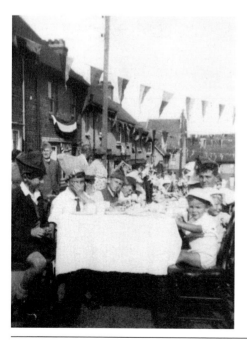

VE Day: Tuesday, 8 May 1945 – the day they had all been waiting for. We had won the war after nearly six weary years of fighting. This is the street party held in Highwell Road, Seaton, to celebrate the great victory. Standing on the left is the Seaton vicar, the Revd H.R. Cooke MC, who visited many of the street parties held on that day.

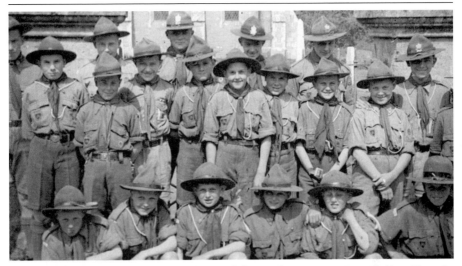

The 1st Beer Scout Troop, 1944. Back row, left to right: Norman Russell, Reg Chapple, Peter Lockyer, Robert Bogan, Alan Cartlidge, Alec Perkins. Middle row: Eric Westlake, Mervyn Clarke, Roy Chapple, John Underwood, Clive Thorne, Thomas Abbott, Lewis Perkins, Gerald Bartlett, Robbie Driver. Front row: Michael Collier, Tony White, Ron Wilkins, Alan Abbott, Sydney Carter, Percy Westlake.

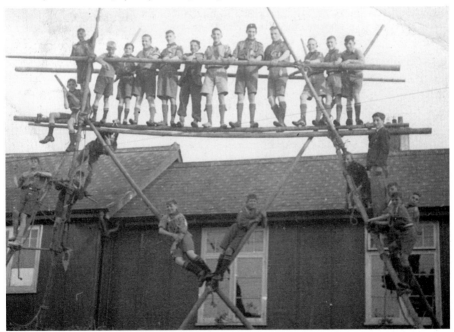

1st Beer Scout Troop building a bridge outside the Scouts Hall, 1944. The scouts served as official messengers to the Home Guard for which they earned a National Service ribbon.

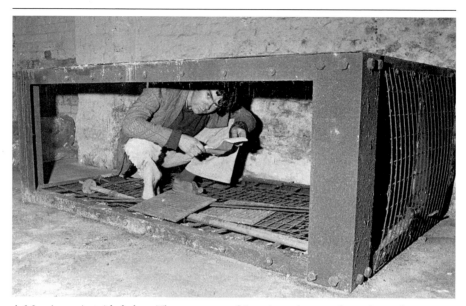

A Morrison air raid shelter. These were used in private houses throughout the country during the Second World War. These indoor shelter beds, 6ft 6in long and 4ft wide, were named after the Rt Hon Herbert Morrison and were provided free to householders whose annual income was £350 or less. To others they cost £8 each. This picture was taken over thirty years after the war when an *Express and Echo* reporter tried it for size.

Troop Leader Ronald Anning and Patrol Leader William Green, August 1943. They are wearing their Scout gilt crosses which were presented to them for gallantry by Colonel O'Donnell, the Assistant County Commissioner, at a ceremony in the Church Institute, Seaton. They were by the River Axe when they noticed that a child had entered the river from the other side and was in difficulties. The child, 12-year-old Connie Wall, was half-way across and had gone under twice by the time the two men reached her. They succeeded in getting her to the side of the river and their plucky rescue saved the girl from drowning.

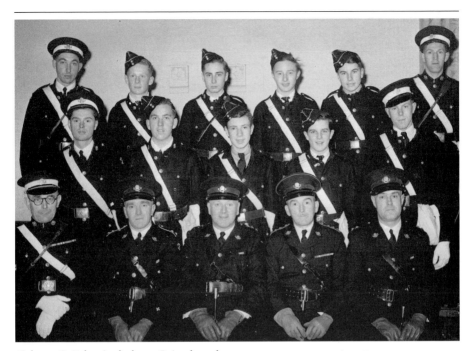

Colyton St John Ambulance Brigade cadets.

Miss Daphne Harman Young sitting on the wrecked tank landing craft HM LCT 1137 at Seaton, *c*. 1945. This craft suffered damage on D-Day on the Normandy beaches and broke its back on the return journey. Crew members managed to secure the broken halves with chains, but navigation proved difficult and instead of returning to its base at Portland it ended up on Seaton Beach.

THE BREAD CODE

1 Buy only as much bread as you know you will need. Don't buy a large loaf if a small one will do.

2 Don't ask for bread in a restaurant unless you mean to eat it.

3 Learn how to keep bread fresh; it should be wrapped in a clean, dry cloth, and kept in an airy place. If you use a bin, see that it lets in air—either by air-holes or keeping the lid tilted.

4 If, in spite of your care, you sometimes get stale ends, use them up in cooking—or, as a last resort, put them in the pig-food bin. Never, *never* put them in the dustbin.

Issued by Ministry of Food June 1946 6498106

This pamphlet was issued by the Ministry of Food in an effort to save bread.

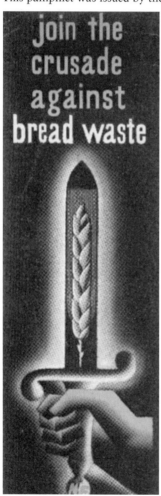

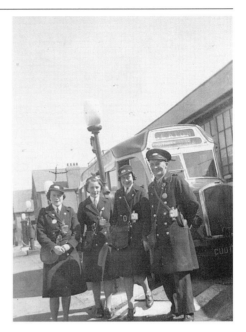

Wartime bus conductresses Dorothy Kitty Andrews and Peg Seager photographed with bus driver Giles White from Beer at the Station Road Bus Depot, Seaton, 1942. During the Second World War the courage, action and endurance of Britain's women was evident in all areas and walks of life – in the Army, the Navy and the Air Force, at fire brigade stations; Land Army Girls worked in the fields and in factories, and they all took their turn at firewatching.

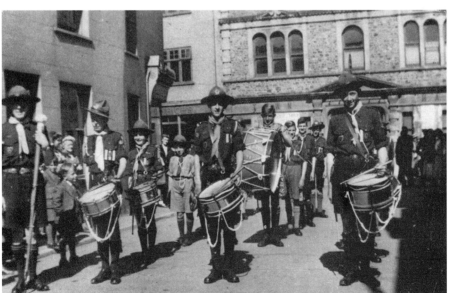

Seaton Scout Band on parade in Cross Street, Seaton, c. 1943. The band was playing for the opening ceremony of the Seaton, Colyton, Beer and District Wings for Victory Week on Saturday, 22 May 1943. The target for the week was £50,000 which would have bought one bomber and two Typhoons. Members of the band included Ron Anning, Bill Green, Ted Gosling, Ray Turner, Bill Moulding, Don Rodgers and Ray Fox. Standing to the left of the band is the Scoutmaster, 'Skipper' Brookes.

CLOTHING BOOK 1947-48
GENERAL CB 1/10

This book must not be used until the holder's name, full postal address and National Registration Number have been written below. Detach this book at once and keep it safely. It is your only means of buying clothing.

HOLDER'S NAME ▓▓▓▓▓▓▓▓▓
(in BLOCK letters)

ADDRESS ▓▓▓▓ HAVENVIEW RD.
(in BLOCK letters)

SEATON. DEVON.

HOLDER'S NATIONAL REGISTRATION No.

BEDZ / 214 / 2.

IF FOUND please take this book to any Food Office or Police Station

FOOD OFFICE CODE No.

S.W. 129

THIS BOOK IS NUMBER

AC 511807

Local Clothing Ration Book. On 1 June 1941 Oliver Lyttelton, then president of the Board of Trade, announced his scheme for the immediate rationing of clothing, including footwear; although this was to cause hardship to some people, most of the population managed with the yearly allowance of sixty-six clothing coupons. An adult's mac or raincoat required sixteen of the precious coupons, a pair of trousers eight, a pair of boots or shoes seven and a pair of socks three. Knitters had to part with two coupons for one ounce of wool.

C.B. 2/9

How to use this book

1. This Clothing Book must be detached immediately from the Food Ration Book (see page I); and the holder's name, full postal address and National Registration number written in the spaces provided on page I in INK.

2. All the coupons in this book do not become valid at once. IT IS ILLEGAL TO USE ANY COUPON UNTIL IT HAS BEEN DECLARED VALID.

3. When shopping, you must not cut out the coupons yourself, but must hand this book to the shopkeeper and let him cut them out. IT IS ILLEGAL FOR THE SHOPKEEPER TO ACCEPT LOOSE COUPONS.

4. When ordering goods by post, do not send this book—cut the coupons out, and send them with your order BY REGISTERED POST.

5. The Clothing Books of deceased persons must be handed to the Registrar of Births and Deaths when the death is notified.

6. This book is the property of H.M. Government and may only be used by or on behalf of the person for whom it is issued. TAKE GREAT CARE NOT TO LOSE IT.

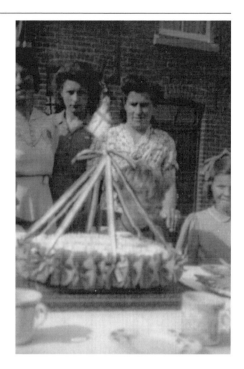

Mrs George Bazeley, Mrs Eric Munday and Mrs Reg Jones admiring the Highwell Road Party cake at the VE Day celebrations in Highwell Road, Seaton, 8 May 1945.

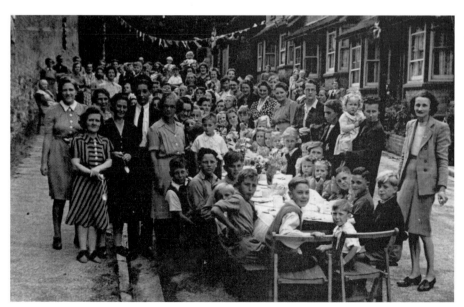

VE Day street party in Brewery Lane, Sidmouth, 8 May 1945. For the people in Brewery Lane, as elsewhere, it was a time not just to celebrate but also to remember with pride all those who had rendered service in those dark days, now past.

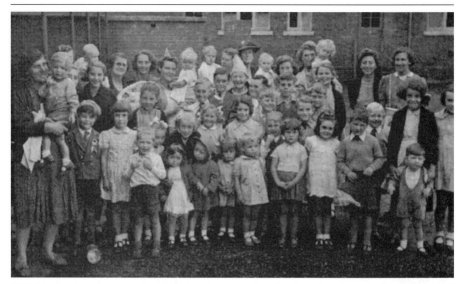

Children and parents posing for the photographer in the playground of Exeter Road School, Exmouth, during the victory celebrations in 1945.

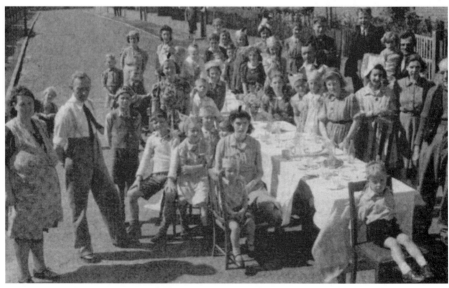

VE Day street party in Greenhill Avenue, Exmouth, May 1945. Among those pictured are Mr and Mrs Coles, Mr Phillips, Mr and Mrs Bridle, Ivy Gillard, Pauline Gillard, Rita and Rhona Parker, Grace Coles, Chico Frayne, Mrs Parkhouse, Jack Parkhouse, Joan and Eileen Tyler, Doreen Bridle and David Hine.

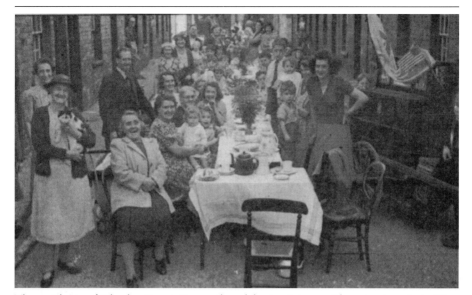

The residents of Charles Street, Exmouth, celebrate victory with a street party in May 1945. The lady in the front on the left holding a cat is Mrs Perriam; standing behind her is Elsie Fisher. The barrel organ on the right is being played by Romeo Reynolds, a well-known local character.

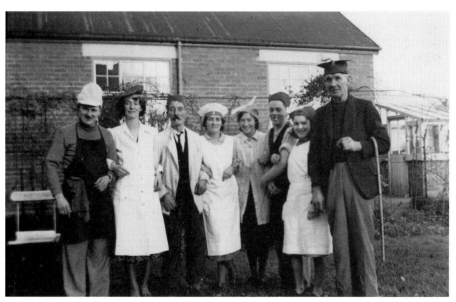

The staff of the Pole Arms Hotel in the garden, Christmas 1944. Left to right: the well-known 'Nippy' Ball (saddler and barman), Gladys (waitress), George (potman), Mrs Meyer, (the licensee's wife), Hetty (chambermaid), Percy (cellarman), Ivy (chambermaid), Bill (gardener).

BILLETING
INSTRUCTIONS REGARDING ISSUE OF FORMS

The form and counterfoil should be completed by the billeting officer in ink or indelible pencil, including the name of the Post Office at which payments will be made. It is essential that the full and precise name of the Post Office should be entered.

The full name and address of the occupier should be filled in.

The full name of each child should be filled in, a line being allowed for each child. Any unused space should be cancelled.

The total number of children provided with accommodation at the premises should be filled in, and the total amount payable per week to the occupier should be entered in words and figures.

Payment should be authorised (a) from the date on which the accommodation is provided in the case of initial billeting, or (b) from the next due date of payment where the form is issued in renewal of an existing form.

The billeting officer should sign and date the form.

The counterfoil should be completed with all the particulars entered on the form. and signed by the billeting officer.

The form should be handed to the occupier. Any previous form should be withdrawn.

The counterfoils should be carefully preserved by the billeting officer.

(5/517) Wt. 54021/595. 60M. bks. 1/40. B. & S. Ltd. 51-6154.

Evacuee billeting form, 1939. Within hours of the outbreak of war children from the cities were making their way by train to the safety of the countryside. Homes throughout East Devon welcomed those children. These forms were used by the local billeting officer.

Wartime soap advertisement, *c.* 1943.

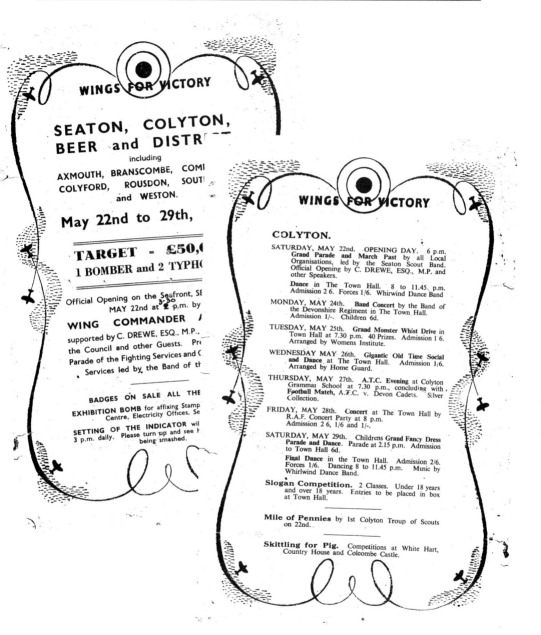

WINGS FOR VICTORY

SEATON, COLYTON, BEER and DISTR---

including

AXMOUTH, BRANSCOMBE, COMI
COLYFORD, ROUSDON, SOUTI
and WESTON.

May 22nd to 29th,

TARGET - £50,(

1 BOMBER and 2 TYPH(

Official Opening on the Seafront, SE
MAY 22nd at 3.30 p.m. by

WING COMMANDER /

supported by C. DREWE, ESQ., M.P.,
the Council and other Guests. Pr
Parade of the Fighting Services and (
Services led by the Band of th

BADGES ON SALE ALL THE

EXHIBITION BOMB for affixing Stamp
Centre, Electricity Offices, Se

SETTING OF THE INDICATOR wil
3 p.m. daily. Please turn up and see f
being smashed.

WINGS FOR VICTORY

COLYTON.

SATURDAY, MAY 22nd. OPENING DAY. 6 p.m.
Grand Parade and March Past by all Local
Organisations, led by the Seaton Scout Band.
Official Opening by C. DREWE, ESQ., M.P. and
other Speakers.

Dance in The Town Hall. 8 to 11.45 p.m.
Admission 2 6. Forces 1/6. Whirwind Dance Band

MONDAY, MAY 24th. **Band Concert** by the Band of
the Devonshire Regiment in The Town Hall.
Admission 1/-. Children 6d.

TUESDAY, MAY 25th. **Grand Monster Whist Drive** in
Town Hall at 7.30 p.m. 40 Prizes. Admission 1 6.
Arranged by Womens Institute.

WEDNESDAY MAY 26th. **Gigantic Old Time Social
and Dance** at The Town Hall. Admission 1/6.
Arranged by Home Guard.

THURSDAY, MAY 27th. **A.T.C. Evening** at Colyton
Grammar School at 7.30 p.m., concluding with
Football Match, A.T.C. v. Devon Cadets. Silver
Collection.

FRIDAY, MAY 28th. **Concert** at The Town Hall by
R.A.F. Concert Party at 8 p.m.
Admission 2 6, 1/6 and 1/-.

SATURDAY, MAY 29th. **Childrens Grand Fancy Dress
Parade and Dance.** Parade at 2.15 p.m. Admission
to Town Hall 6d.

Final Dance in the Town Hall. Admission 2/6.
Forces 1/6. Dancing 8 to 11.45 p.m. Music by
Whirlwind Dance Band.

Slogan Competition. 2 Classes. Under 18 years
and over 18 years. Entries to be placed in box
at Town Hall.

Mile of Pennies by 1st Colyton Troup of Scouts
on 22nd.

Skittling for Pig. Competitions at White Hart,
Country House and Colcombe Castle.

Left: Programme for the Wings for Victory Week, 22–29 May 1943. The target for the week was to raise £50,000 which would buy one bomber and two Typhoons. Right: The programme of events in Colyton during the Wings for Victory Week, 22 to 29 May 1943. The Seaton Scout Band led by 'Skipper' Brooks led the opening parade after marching from Colyford station.

The banner party of the Seaton Girl Guides photographed in the garden of their captain, Miss Vivian, *c.* 1943. Left to right: Audrey Meyer, Ann Bellers, Deryn O'Connor.

This granite cross was erected in Axmouth churchyard in memory of the men from the village who fell in the First World War.

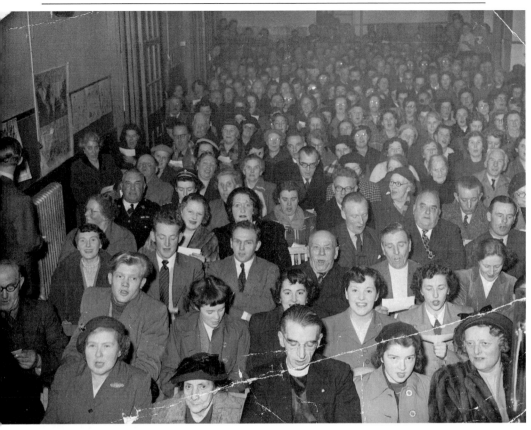

After the Second World War (but before the advent of television) most families gathered in the evenings around a wireless set. The new light programme attracted a huge audience and programmes such as 'Down Your Way' and 'Twenty Questions', and entertainers such as Wilfred Pickles had over fifteen million listeners. The people of Beer gathered in their school to enjoy the excitement when Wilfred Pickles broadcast his programme live from the village in about 1947.

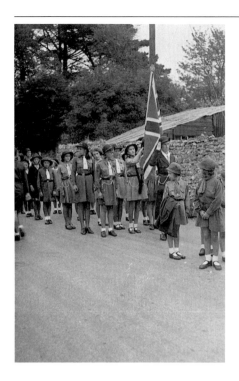

Seaton Girl Guides on parade for the Seaton, Colyton, Beer and District Wings for Victory Week, May 1943.

WISH TO MARK, BY THIS PERSONAL MESSAGE,
my appreciation of the service you have rendered to your
Country in 1939.
In the early days of the War you opened your door to strangers
who were in need of shelter, & offered to share your home with
them.
I know that to this unselfish task you have sacrificed much
of your own comfort, & that it could not have been achieved
without the loyal co-operation of all in your household.
By your sympathy you have earned the gratitude of those to
whom you have shown hospitality, & by your readiness to
serve you have helped the State in a work of great value.

Elizabeth R

This personal message from the Queen was sent to Mrs V. Webster thanking her for giving shelter to the evacuees.

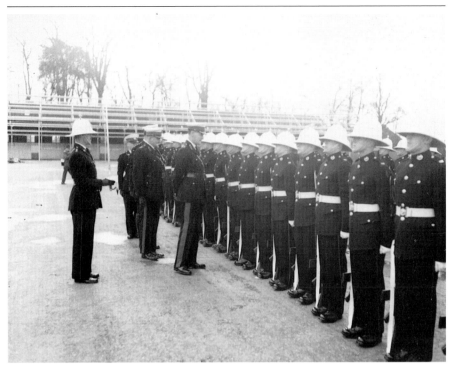

Royal Marines at a passing out parade, Lympstone Camp, *c.* 1955.

A special commemorative D-Day service was held on 5 June 1994 at Holy Trinity Church, Exmouth. During the service Canon Ken Middleton of Holy Trinity Church unveiled a commemorative plaque, while Chairman of the Town Committee Jill Elson planted a tree.

MUSIC HALL VARIETY SHOW

Under the auspices of the Seaton Chamber of Commerce

PROGRAMME

1. THE SIX ACES SWING SEXTET Salute the Soldier Melodies
 1. Sing Everybody Sing.
 2. This is the Army Mr. Jones.
 3. Johnny Zero.

2. DRAMATIC EPISODE - The Brass Door-Knob
 Mrs. BRADBURY - Peggy Wilson.
 Mr. HAWKER - Arthur Bilham.
 Scene—Mrs. Bradbury's sitting-room in a London flat.

3. JOE BEER - - - The Rollicking Songster
 1. The Galloping Major.
 2. Mother Machree.
 3. My Latchkey.
 Accompanist—Peter Payne.

4. WILLIAM GRAY & JOSEPH DRUKKER on Two Grand Pianos
 1. Gems from Liszt's Hungarian Rhapsody.
 2. Rustle of Spring.
 3. Tchaikovsky's Concerto.

5. DAVID BURNSIDE - Character Study—The Red Rose
 Scene—A Flower Shop.

6. CAN YOU LEAD THE BAND ?
 Will members of the audience who wish to compete,
 go on the stage as quickly as possible when requested
 by the compere !

7. BETTY CHARLEY - - Renowned Soprano
 1. The Thrush's Love Song.
 2. Sing Joyous Bird.
 Accompanist—William C. Walton.

8. THE WORLD FAMOUS COMEDY A Sister to assist 'er
 Mrs. MAY - Arthur Bilham,
 Mrs. McCULL - William Gray.
 Scene—A bed-sitting room in a poor-class lodging house.

9. SIX ACES SWING SEXTET
 1. Melodies of the Gay Nineties.
 2. There'll always be an England.

 GOD SAVE THE KING.

E. J. Burnham, Seaton.

The programme of a music hall variety
show held at the Seaton Town Hall in
aid of Salute the Soldier Week.

ARRANGEMENTS FOR THE DAY

VALOUR, ENDURANCE AND FAITH
IN A RIGHTEOUS CAUSE GAVE
OUR COUNTRY A GREAT AND
GLORIOUS VICTORY,
TOGETHER LET US THANK GOD

10.30. Service, Ex-Service Men and Women,
 Home Guard, Civil Defence Workers,
 Scouts, Guides, and all who con-
 tributed to the War Effort, will
 assemble at the Schools and Parade
 to Church.

 In command of Parade :
 Lieut.-Commander W. Lockyer, R.N.

11.0. United Service in the Parish Church
 conducted by the Vicar, Rev. W. H.
 Dormor, Chaplain, R.N.V.R.

" Cast Care and Trouble Aside,
 and Let Us Merry Be "

2.0. Children Assemble at the Schools
 in Fancy Dress and Parade to the
 Cliff.

4.0. Tea for Children in Main Street.

5.30. Maypole and Folk Dancing on the Cliff.

6.30. General Sports in Main Street.

7.30. Whist Drive, R.A.O.B. Room, Dolphin
 Hotel.

8.30. Fun and Games and Furry Dance on
 Cliff.

11.0. Bonfire on West Beach, to be lit by
 Mrs. Dormor.

 AULD LYNE SYNE
 GOD SAVE THE KING

Souvenir programme for the Beer Victory Celebrations, 8 June 1946.

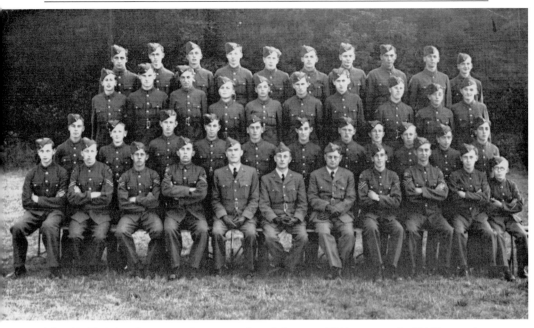

The Air Training Corps was inaugurated on 9 January 1941 to meet the RAF's growing demand for pilots and air crews. All boys over sixteen who were physically fit and wished to serve in the Air Force could join. This is 1067 ATC Squadron, which was formed at Colyton Grammar School during the Second World War but did not draw exclusively on school pupils for its members. The three officers in the front row, all members of the school staff, are Mr Jowett, Mr Montgomery and Mr Slade.

I have received The King's command to express His Majesty's appreciation of the loyal service given voluntarily to her country in a time of grievous danger by Mrs. H. CHAPPEL

as a Woman Home Guard Auxiliary.

The War Office,
London.

Secretary of State
for War

This certificate was awarded to Mrs H. Chapple from Beer, 1945.

The Seaton Branch of the Royal British Legion was formed during the Second World War. Here Branch Chairman Revd H.R. Cooke MC is shown discussing the lease of the new headquarters in the Regal Cinema. Left to right: Revd H.R. Cooke (Chairman), E.S. Gosling (Secretary), A. Gardner (Vice-Chairman).

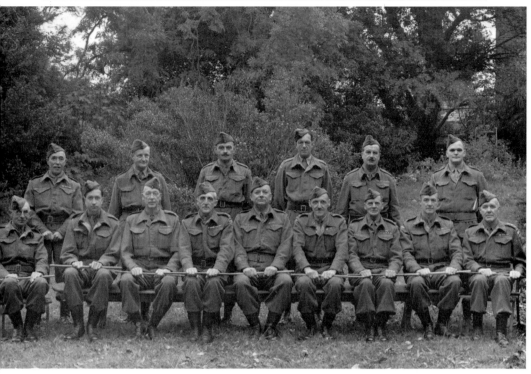

Officers of the Home Guard, Exmouth and Budleigh district, *c.* 1944. Palmer House now stands here, in the garden of The Lawn at the extreme end of West Terrace, Exmouth. Front row, left to right: Lt. H.S. Sutherland, Lt. A Beach, Lt. C.R. Rickeard, Capt. A.C.G. Roberts MC, Maj. J.W. Palmer, Lt. R.T. Anderson, Lt. S.C. Caffyn, Lt. A.R. Smith, Capt. T.C.C. Evans DSO. Back row: Lt. J.M. Pavey, Lt. W.A. Ingham, 2nd Lt. W.A. Britton, 2nd Lt. A.F. Pratt, 2nd Lt. K.H. Coxe MC, Lt. J.F.R. Richards.

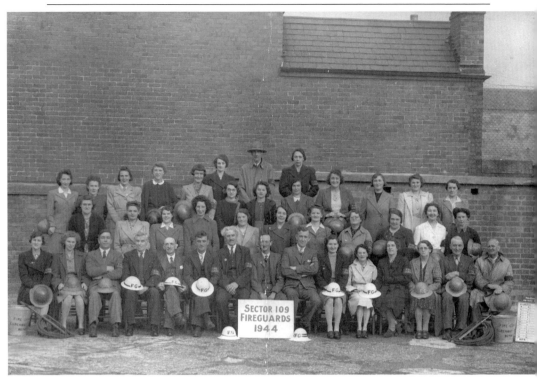

Sector 109 Fireguards, Exmouth, 1944. Fireguards played their part in civilian defence during the Second World War. During air raids they patrolled various areas on the lookout for incendiary bombs. Front row, left to right: G. Howe-Haysom, W. Hall, A. Dommett, J. Southwell, H. Hynard, W. Bond, G. Hall, B.H. Avery (Sector Capt.), P. Milford, R. Ridley, A. Carpenter, L. Bradford, A. Moist, ? Moist, H.A. Johnson. Second row: D. Dymond, E. Madge, E. Letten, E. Smith, I. Tozer, L. Stubbington, M. Fryer, A. Roach, L. Underwood, A. Thompson, V. Dobel. Third row: M. Tucker, D. Seagroatt, E. Richards, E. Pidgeon, D. Salmon, L. Bell, E. Williams, M. Oxford, K. Maers, D. Southwell, M. Ridley, F. Humphries. Back row: H. Bond, A. Backhouse, M. Bond.

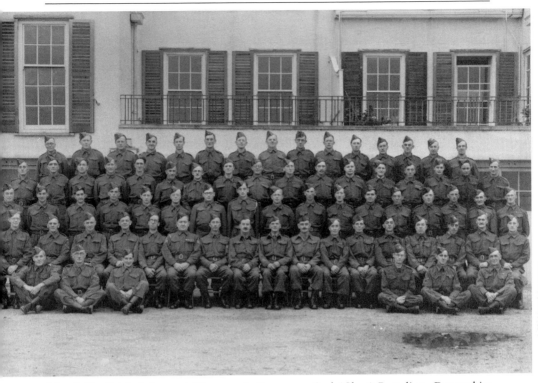

No. 2 (Budleigh Salterton) Platoon, A Company, 2nd (Clyst) Battalion, Devonshire Regiment Home Guard, at Highbury on the seafront, Exmouth, *c.* 1943. Front row, left to right: L/Cpl L.W. Weaver, L/Cpl G.L. Brown, Pte I. Collier, Pte R. Stainer, L/Cpl W.G. Prew, L/Cpl P.J. Hunt. Second row: Cpl J.H. Parker, Cpl P. Gooding, Cpl C.E. Mears, Cpl F.J. Spargo, L/Sgt D.G. Mears, Sgt E.W. Endicott, Pl Sgt G.H. Hayward, 2nd Lt. K.H. Coxe MC, Lt. S.C. Caffyn, 2nd Lt. W.A. Britton, Sgt W. Harris, Sgt A.H.M. Jacoby, L/Sgt W. Pratt, Cpl G. Willis, Cpl B.G. Smith, Cpl C.A. Smith, Pte F.B. Smale. Third row: Pte H.L. Harris, Pte F.W. Preston, Pte F.J. French, Pte J.H. Vanstone, Pte J.E.G. Erskine, Cpl A.H. Boxall, Pte G. Grant, Pte R.L. Pearcey, L/Cpl G. Widdicombe, Pte A.E. Chard, Pte H.H. Fowler, Pte J.J.E. Statham, Pte W.F. Gooding, L/Cpl W.J. Eales, Pte D.H. Pidgeon, L/Cpl H.A. Sellek, L/Cpl A.C. Baker. Fourth row: L/Cpl W. Beer, Pte G.J. Jackson, Pte A.G. Tonkin, Pte R.W. Smith, Pte H. Carnell, Pte C.J. Fayter, L/Cpl W. Selley, L/Cpl G.D. Clarke, Pte J.R. Bowles, Pte G.H. Mears, Pte A.C. Ellis, L/Cpl H.G. Brookes, Pte R. Stone, L/Cpl J.E. Morris, Pte P. Bolton, Pte J.W. Williams, Pte W.J. Goodheart. Back row: Pte P.A. Rendell, Pte C.F. Sage, Pte R.W. Sellek, L/Cpl R. Pratt, Pte E.F. Watts, Pte E.E. Hayman, Pte T.V. Foley, Pte C. Acland, Pte L.H. Burch, Pte K.H. Sellek, Pte S.J. Westlake, Pte F. Alford, Pte M.B. Keslake, Pte F.W. Powlesland, Pte F.C. Keslake.

Section Seven

FROM FOREIGN SHORES

Many were those who came from foreign lands to build up the Allied Forces in preparation for D-Day. The Czechs and Poles have already been mentioned, and while they were stationed in East Devon many lasting friendships were made; some even returned after the war to settle in the area.

The Americans made the greatest impact, the first ones operating out of Dunkeswell and Smeatharpe airfields. Later came the big build-up to D-Day when the countryside became full of military convoys. Along the lanes and in the woods were parked long lines of jeeps, trucks and transporters, many covered with camouflage netting. And one day they all just disappeared, as they proceeded to their embarkation points further up the coast.

Finally it was the turn of the Italian prisoners of war, who were allowed to help on the farms and other important work.

The American hospital at Millwey Rise, Axminster, *c.* 1944. Taken from the water tower at the top of the camp, this view down to Chard Road shows the hospital wards and a covered way.

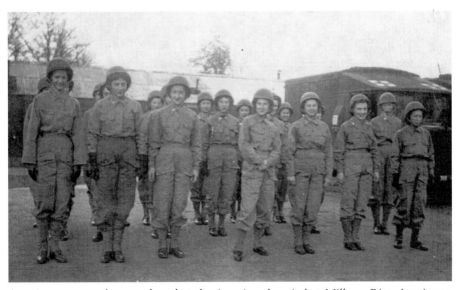

American nurses who were based at the American hospital at Millwey Rise, Axminster, *c.* 1944.

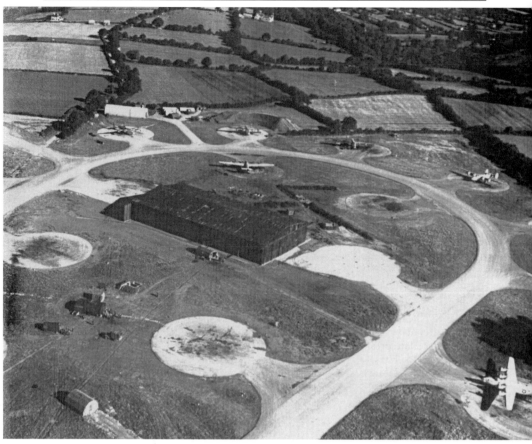

Dunkeswell was home to the US Navy Air Arm Wing 7 during the Second World War. This 1944 aerial view of the Dunkeswell airfield dispersal area shows five parked Liberators and a Flying Fortress.

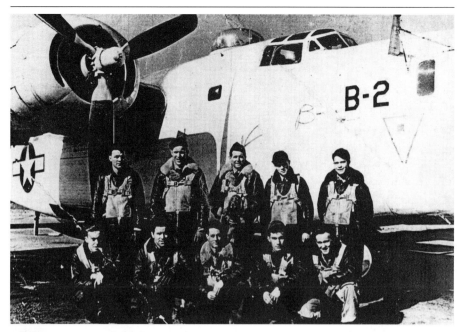

Joseph P. Kennedy (centre rear) with his crew, Dunkeswell, summer 1944. The eldest brother of the late president John F. Kennedy, Joseph was born in Hull, Massachusetts, on 25 July 1915. He served as a pilot in the US Navy Air Arm flying PB4Ys (known as Liberators). On 12 August 1944, twenty-four minutes after his plane had taken off from Dunkeswell it exploded in the air over Blythburgh, Suffolk, killing the entire crew, and with the loss to the United States of a potential president.

Some local people resented the Americans, but there was a touch of Hollywood glamour about their accent, and dressed in off-duty casual clothes they must have appeared unbelievably exotic to the local girls. Here members of patrol crew no. 17 are waiting outside Dunkeswell post office to phone their girlfriends in about 1944. Left to right: S/1C W. Raven (in phone box), ARM/2C E.J. Riffin, AMM/1C E.R. Burfield, AMM/1C E.E. Stoner, AOM/2C D.H. Noodin.

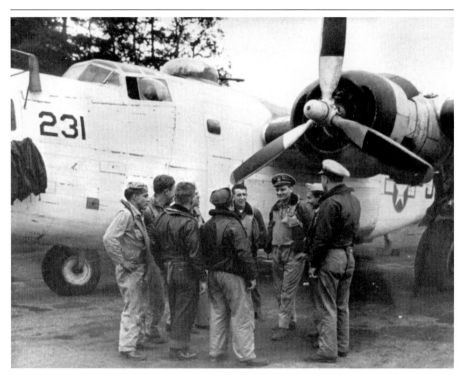

American aircrew briefing in front of a PB4Y–1 (known as a Liberator) at wartime Dunkeswell.

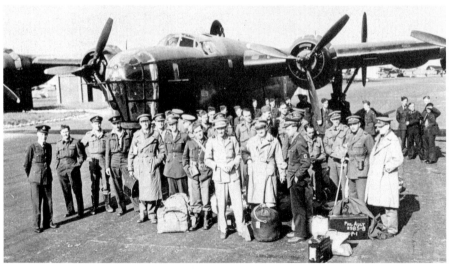

American airmen from the 1st Navy Squadron posing in front of a Liberator at Dunkeswell, *c.* 1944.

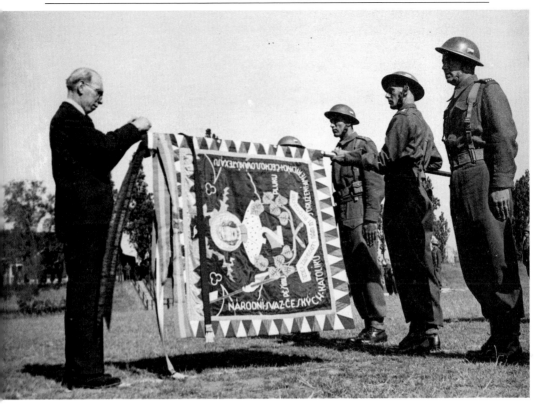

Presentation to the Czech Army, 1943. Frank Norcombe, Chairman of Seaton Urban District Council, and Francis Garner, Clerk to the Council, visited Dover Court, near Harwich, accompanied by their wives, and on this occasion Frank Norcombe attached a ribbon to the colours of the 2nd Battalion Czech Army who were stationed at Seaton for part of the war. Some of the Czechs returned to Seaton after the war and were able to renew their acquaintance with Frank.

Frank Norcombe, Chairman of Seaton Urban District Council, with other dignitaries at Dover Court in 1943 for the presentation of a Ribbon to the Colours of the 2nd Battalion Czech Army.

The colours of the 2nd Battalion Czech Army with the ribbon from Seaton attached. The words read: 'To the 2nd Batt. Czechoslovak Army from Seaton, Devon, greetings, remembrances and gratitude.'

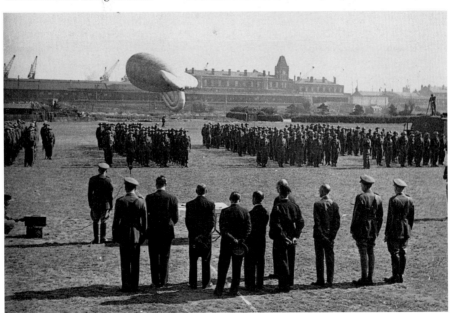

The Czech Army 2nd Battalion on parade at Dover Court in 1943 during the presentation of a Ribbon to their Colours by Frank Norcombe, Chairman of Seaton Urban District Council.

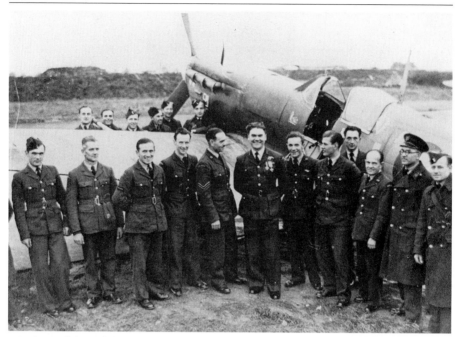

Members of the Polish Fighter Squadron based at Exeter Airport, 1941.

226 Squadron at Exeter Airport, *c.* 1943. The two-man band of the Rhodesia Fighter Squadron entertaining their fellow pilots while on stand-by for action. The Rhodesian Squadron, whose pilots all came from Rhodesia, was one of the most famous in Fighter Command. Based at Exeter Airport, they flew Typhoons and played a very large part in deterring the tip-and-run raiders who were threatening to put East Devon out of action.

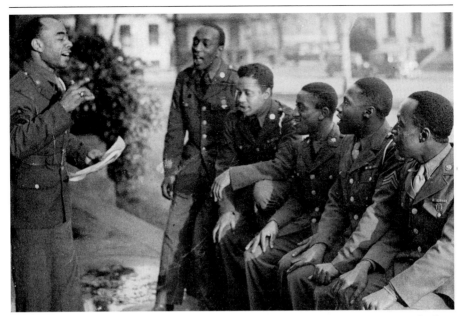

American troops in East Devon, *c.* 1944. Coloured American troops, with their traditional love for singing, provided plenty of talent for service shows. Here Sgt Eskridge of Chicago is rehearsing some of his men for a concert.

IN MEMORIAM

THE WORLD'S UNKNOWN SOLDIER
KILLED IN
WORLD WAR II

All honor to him, friend or foe,
Who fought and died for his country!

May the tragedy of his supreme
Sacrifice bring to us, the living,
Enlightenment and inspiration;
Fill us with ever-mounting zeal
For the all-compelling quest of peace,
World peace and universal brotherhood.

Erected by the Ryozen Kannon Kai, Kyoto,
June 8, 1958

This epitaph is carved on the monument of the unknown soldier of the Second World War.

The above "Epitaph" is carved on the monument of The Unknown Soldiers World War II
上記は世界無名戦上碑文であります

123

CAUGHT LIKE FOXES IN A TRAP

English and American soldiers !

Why has Jerry waited ten days after the landings to use his so called secret weapon behind your back ? Doesn't that strike you as queer ?

It looks very much as though after waiting for you to cross the Channel, he had set a TRAP for you.

You're fighting at present on a very narrow strip of coast, the extent of which has been so far regulated by the Germans.

You are using up an enormous number of men and huge quantities of material.

Meanwhile the Robot-planes, flying low, scatter over London and southern England explosives, the power and incendiary efficiency of which are without precedent. They spread death and destruction in the towns and harbours, which should be sending you much needed supplies.

They are cutting the bridge to your bases

In addition to the destruction and panic at home, traffic is disorganised, ships, even hospital ships, are held up.

How long can you keep up this foolish invasion in those circumstances ?

It's up to you to think of the best way to get out of the TRAP in wich you are CAUGHT.

Time is precious. To-morrow may be too late.

Copy of one of the leaflets dropped by German planes over Allied troops on D-Day Plus 10.

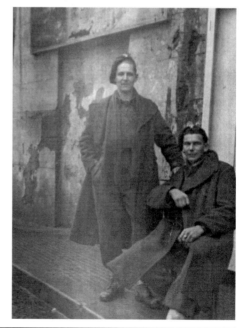

Corporal E. Munday (seated) from Seaton and GDSN Russell (standing) from Birmingham, serving with the 5th Battalion Grenadier Guards in Italy, *c.* 1944.

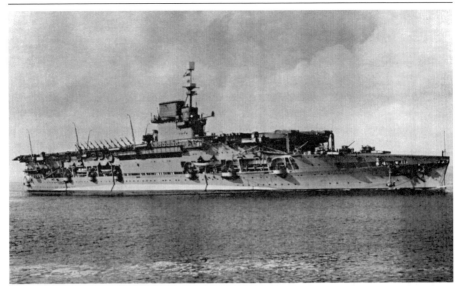

The aircraft carrier HMS *Courageous* was torpedoed and sunk by U–29 west of Ireland on 17 September 1939 with a loss of 518 lives. Many men from East Devon served on the *Courageous*, commanded by Captain J.R. Makeig-Jones who lived at Beerhill Cottage, Seaton, and who went down with his ship.

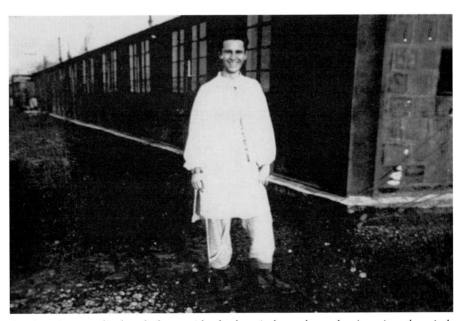

An American medical orderly outside the hospital wards at the American hospital, Millwey Rise, Axminster, *c.* 1944. After the war the hospital was converted into housing.

Acknowledgements

We are grateful to the many people who have contributed material for this book. Particular thanks must go to the Editor of the *Express and Echo* for allowing us to use pictures from their archives. Thanks also to the *Sidmouth Herald* for permission to use material, to the Axe Valley Heritage Museum, the Axminster Museum, and the Allhallows Museum at Honiton who helped with loans of photographs. Special thanks must also go to the following people without whose photographs and advice this book would not have been possible:

Les Boalch • Ken Gould • Mr and Mrs R. Aplin • May Clapp • Des Garrett
Alan Trott • Mr Dawe • Nobby Clarke • Bill Turton • Ron Anning
Gerald Oborn • John Underwood • R. Lawrence • G. Bastone • Betty Barr
Ian Thomas • Eric Munday • Lan Mutter • Maurice Turner • Jack Morgan
Ernest Beer • Derek Fox • Mr Stentiford • Ray Driver • Taffy Pugsley
Bob Britton • Arthur Chapple.

Special thanks must also go to Linda Turner and Edna Everitt who gave much appreciated assistance.

We are grateful to our wives for their encouragement and help, and also to Simon Fletcher of Alan Sutton Publishing Limited for his assistance.

The quiet courage of the First and Second World War generations shone through, and showed why this country deserved to be known as Great Britain.

Ted Gosling & Roy Chapple

BRITAIN IN OLD PHOTOGRAPHS

To order any of these titles please telephone Littlehampton Book Services on 01903 721596

ALDERNEY

Alderney: A Second Selection, *B Bonnard*

BEDFORDSHIRE

Bedfordshire at Work, *N Lutt*

BERKSHIRE

Maidenhead, *M Hayles & D Hedges*
Around Maidenhead, *M Hayles & B Hedges*
Reading, *P Southerton*
Reading: A Second Selection, *P Southerton*
Sandhurst and Crowthorne, *K Dancy*
Around Slough, *J Hunter & K Hunter*
Around Thatcham, *P Allen*
Around Windsor, *B Hedges*

BUCKINGHAMSHIRE

Buckingham and District, *R Cook*
High Wycombe, *R Goodearl*
Around Stony Stratford, *A Lambert*

CHESHIRE

Cheshire Railways, *M Hitches*
Chester, *S Nichols*

CLWYD

Clwyd Railways, *M Hitches*

CLYDESDALE

Clydesdale, *Lesmahagow Parish Historical Association*

CORNWALL

Cornish Coast, *T Bowden*
Falmouth, *P Gilson*
Lower Fal, *P Gilson*
Around Padstow, *M McCarthy*
Around Penzance, *J Holmes*
Penzance and Newlyn, *J Holmes*
Around Truro, *A Lyne*
Upper Fal, *P Gilson*

CUMBERLAND

Cockermouth and District, *J Bernard Bradbury*
Keswick and the Central Lakes, *J Marsh*
Around Penrith, *F Boyd*
Around Whitehaven, *H Fancy*

DERBYSHIRE

Derby, *D Buxton*
Around Matlock, *D Barton*

DEVON

Colyton and Seaton, *T Gosling*
Dawlish and Teignmouth, *G Gosling*
Devon Aerodromes, *K Saunders*
Exeter, *P Thomas*
Exmouth and Budleigh Salterton, *T Gosling*
From Haldon to Mid-Dartmoor, *T Hall*
Honiton and the Otter Valley, *J Yallop*
Around Kingsbridge, *K Tanner*
Around Seaton and Sidmouth, *T Gosling*
Seaton, Axminster and Lyme Regis, *T Gosling*

DORSET

Around Blandford Forum, *B Cox*
Bournemouth, *M Colman*
Bridport and the Bride Valley, *J Burrell & S Humphries*
Dorchester, *T Gosling*
Around Gillingham, *P Crocker*

DURHAM

Darlington, *G Flynn*
Darlington: A Second Selection, *G Flynn*
Durham People, *M Richardson*
Houghton-le-Spring and Hetton-le-Hole, *K Richardson*
Houghton-le-Spring and Hetton-le-Hole:
 A Second Selection, *K Richardson*
Sunderland, *S Miller & B Bell*
Teesdale, *D Coggins*
Teesdale: A Second Selection, *P Raine*
Weardale, *J Crosby*
Weardale: A Second Selection, *J Crosby*

DYFED

Aberystwyth and North Ceredigion,
 Dyfed Cultural Services Dept
Haverfordwest, *Dyfed Cultural Services Dept*
Upper Tywi Valley, *Dyfed Cultural Services Dept*

ESSEX

Around Grays, *B Evans*

GLOUCESTERSHIRE

Along the Avon from Stratford to Tewkesbury, *J Jeremiah*
Cheltenham: A Second Selection, *R Whiting*
Cheltenham at War, *P Gill*
Cirencester, *J Welsford*
Around Cirencester, *E Cuss & P Griffiths*
Forest, The, *D Mullin*
Gloucester, *J Voyce*
Around Gloucester, *A Sutton*
Gloucester: From the Walwin Collection, *J Voyce*
North Cotswolds, *D Viner*
Severn Vale, *A Sutton*
Stonehouse to Painswick, *A Sutton*
Stroud and the Five Valleys, *S Gardiner & L Padin*
Stroud and the Five Valleys: A Second Selection,
 S Gardiner & L Padin
Stroud's Golden Valley, *S Gardiner & L Padin*
Stroudwater and Thames & Severn Canals,
 E Cuss & S Gardiner
Stroudwater and Thames & Severn Canals: A Second
 Selection, *E Cuss & S Gardiner*
Tewkesbury and the Vale of Gloucester, *C Hilton*
Thornbury to Berkeley, *J Hudson*
Uley, Dursley and Cam, *A Sutton*
Wotton-under-Edge to Chipping Sodbury, *A Sutton*

GWYNEDD

Anglesey, *M Hitches*
Gwynedd Railways, *M Hitches*
Around Llandudno, *M Hitches*
Vale of Conwy, *M Hitches*

HAMPSHIRE

Gosport, *J Sadden*
Portsmouth, *P Rogers & D Francis*

HEREFORDSHIRE

Herefordshire, *A Sandford*

HERTFORDSHIRE

Barnet, *I Norrie*
Hitchin, *A Fleck*
St Albans, *S Mullins*
Stevenage, *M Appleton*

ISLE OF MAN

The Tourist Trophy, *B Snelling*

ISLE OF WIGHT

Newport, *D Parr*
Around Ryde, *D Parr*

JERSEY

Jersey: A Third Selection, *R Lemprière*

KENT

Bexley, *M Scott*
Broadstairs and St Peter's, *J Whyman*
Bromley, Keston and Hayes, *M Scott*
Canterbury: A Second Selection, *D Butler*
Chatham and Gillingham, *P MacDougall*
Chatham Dockyard, *P MacDougall*
Deal, *J Broady*
Early Broadstairs and St Peter's, *B Wootton*
East Kent at War, *D Collyer*
Eltham, *J Kennett*
Folkestone: A Second Selection, *A Taylor & E Rooney*
Goudhurst to Tenterden, *A Guilmant*
Gravesend, *R Hiscock*
Around Gravesham, *R Hiscock & D Grierson*
Herne Bay, *J Hawkins*
Lympne Airport, *D Collyer*
Maidstone, *I Hales*
Margate, *R Clements*
RAF Hawkinge, *R Humphreys*
RAF Manston, *RAF Manston History Club*
RAF Manston: A Second Selection,
 RAF Manston History Club
Ramsgate and Thanet Life, *D Perkins*
Romney Marsh, *E Carpenter*
Sandwich, *C Wanostrocht*
Around Tonbridge, *C Bell*
Tunbridge Wells, *M Rowlands & I Beavis*
Tunbridge Wells: A Second Selection,
 M Rowlands & I Beavis
Around Whitstable, *C Court*
Wingham, Adisham and Littlebourne, *M Crane*

LANCASHIRE

Around Barrow-in-Furness, *J Garbutt & J Marsh*
Blackpool, *C Rothwell*
Bury, *J Hudson*
Chorley and District, *J Smith*
Fleetwood, *C Rothwell*
Heywood, *J Hudson*
Around Kirkham, *C Rothwell*
Lancashire North of the Sands, *J Garbutt & J Marsh*
Around Lancaster, *S Ashworth*
Lytham St Anne's, *C Rothwell*
North Fylde, *C Rothwell*
Radcliffe, *J Hudson*
Rossendale, *B Moore & N Dunnachie*

LEICESTERSHIRE

Around Ashby-de-la-Zouch, *K Hillier*
Charnwood Forest, *I Keil, W Humphrey & D Wix*
Leicester, *D Burton*
Leicester: A Second Selection, *D Burton*
Melton Mowbray, *T Hickman*
Around Melton Mowbray, *T Hickman*
River Soar, *D Wix, P Shacklock & I Keil*
Rutland, *T Clough*
Vale of Belvoir, *T Hickman*
Around the Welland Valley, *S Mastoris*

LINCOLNSHIRE

Grimsby, *J Tierney*
Around Grimsby, *J Tierney*
Grimsby Docks, *J Tierney*
Lincoln, *D Cuppleditch*

Scunthorpe, *D Taylor*
Skegness, *W Kime*
Around Skegness, *W Kime*

LONDON

Balham and Tooting, *P Loobey*
Crystal Palace, Penge & Anerley, *M Scott*
Greenwich and Woolwich, *K Clark*
Hackney: A Second Selection, *D Mander*
Lewisham and Deptford, *J Coulter*
Lewisham and Deptford: A Second Selection, *J Coulter*
Streatham, *P Loobey*
Around Whetstone and North Finchley, *J Heathfield*
Woolwich, *B Evans*

MONMOUTHSHIRE

Chepstow and the River Wye, *A Rainsbury*
Monmouth and the River Wye, *Monmouth Museum*

NORFOLK

Great Yarmouth, *M Teun*
Norwich, *M Colman*
Wymondham and Attleborough, *P Yaxley*

NORTHAMPTONSHIRE

Around Stony Stratford, *A Lambert*

NOTTINGHAMSHIRE

Arnold and Bestwood, *M Spick*
Arnold and Bestwood: A Second Selection, *M Spick*
Changing Face of Nottingham, *G Oldfield*
Mansfield, *Old Mansfield Society*
Around Newark, *T Warner*
Nottingham: 1944–1974, *D Whitworth*
Sherwood Forest, *D Ottewell*
Victorian Nottingham, *M Payne*

OXFORDSHIRE

Around Abingdon, *P Horn*
Banburyshire, *M Barnett & S Gosling*
Burford, *A Jewell*
Around Didcot and the Hagbournes, *B Lingham*
Garsington, *M Gunther*
Around Henley-on-Thames, *S Ellis*
Oxford: The University, *J Rhodes*
Thame to Watlington, *N Hood*
Around Wallingford, *D Beasley*
Witney, *T Worley*
Around Witney, *C Mitchell*
Witney District, *T Worley*
Around Woodstock, *J Bond*

POWYS

Brecon, *Brecknock Museum*
Welshpool, *E Bredsdorff*

SHROPSHIRE

Shrewsbury, *D Trumper*
Whitchurch to Market Drayton, *M Morris*

SOMERSET

Bath, *J Hudson*
Bridgwater and the River Parrett, *R Fitzhugh*
Bristol, *D Moorcroft & N Campbell-Sharp*
Changing Face of Keynsham,
 B Lowe & M Whitehead

Chard and Ilminster, *G Gosling & F Huddy*
Crewkerne and the Ham Stone Villages,
 G Gosling & F Huddy
Around Keynsham and Saltford, *B Lowe & T Brown*
Midsomer Norton and Radstock, *C Howell*
Somerton, Ilchester and Langport, *G Gosling & F Huddy*
Taunton, *N Chipchase*
Around Taunton, *N Chipchase*
Wells, *C Howell*
Weston-Super-Mare, *S Poole*
Around Weston-Super-Mare, *S Poole*
West Somerset Villages, *K Houghton & L Thomas*

STAFFORDSHIRE

Aldridge, *J Farrow*
Bilston, *E Rees*
Black Country Transport: Aviation, *A Brew*
Around Burton upon Trent, *G Sowerby & R Farman*
Bushbury, *A Chatwin, M Mills & E Rees*
Around Cannock, *M Mills & S Belcher*
Around Leek, *R Poole*
Lichfield, *H Clayton & K Simmons*
Around Pattingham and Wombourne, *M Griffiths,*
 P Leigh & M Mills
Around Rugeley, *T Randall & J Anslow*
Smethwick, *J Maddison*
Stafford, *J Anslow & T Randall*
Around Stafford, *J Anslow & T Randall*
Stoke-on-Trent, *I Lawley*
Around Tamworth, *R Sulima*
Around Tettenhall and Codsall, *M Mills*
Tipton, Wednesbury and Darlaston, *R Pearson*
Walsall, *D Gilbert & M Lewis*
Wednesbury, *I Bott*
West Bromwich, *R Pearson*

SUFFOLK

Ipswich: A Second Selection, *D Kindred*
Around Ipswich, *D Kindred*
Around Mildenhall, *C Dring*
Southwold to Aldeburgh, *H Phelps*
Around Woodbridge, *H Phelps*

SURREY

Cheam and Belmont, *P Berry*
Croydon, *S Bligh*
Dorking and District, *K Harding*
Around Dorking, *A Jackson*
Around Epsom, *P Berry*
Farnham: A Second Selection, *J Parratt*
Around Haslemere and Hindhead, *T Winter & G Collyer*
Richmond, *Richmond Local History Society*
Sutton, *P Berry*

SUSSEX

Arundel and the Arun Valley, *J Godfrey*
Bishopstone and Seaford, *P Pople & P Berry*
Brighton and Hove, *J Middleton*
Brighton and Hove: A Second Selection, *J Middleton*
Around Crawley, *M Goldsmith*
Hastings, *P Haines*
Hastings: A Second Selection, *P Haines*
Around Haywards Heath, *J Middleton*
Around Heathfield, *A Gillet & B Russell*
Around Heathfield: A Second Selection,
 A Gillet & B Russell
High Weald, *B Harwood*
High Weald: A Second Selection, *B Harwood*
Horsham and District, *T Wales*

Lewes, *J Middleton*
RAF Tangmere, *A Saunders*
Around Rye, *A Dickinson*
Around Worthing, *S White*

WARWICKSHIRE

Along the Avon from Stratford to Tewkesbury, *J Jeremiah*
Bedworth, *J Burton*
Coventry, *D McGrory*
Around Coventry, *D McGrory*
Nuneaton, *S Clews & S Vaughan*
Around Royal Leamington Spa, *J Cameron*
Around Royal Leamington Spa: A Second Selection,
 J Cameron
Around Warwick, *R Booth*

WESTMORLAND

Eden Valley, *J Marsh*
Kendal, *M & P Duff*
South Westmorland Villages, *J Marsh*
Westmorland Lakes, *J Marsh*

WILTSHIRE

Around Amesbury, *P Daniels*
Chippenham and Lacock, *A Wilson & M Wilson*
Around Corsham and Box, *A Wilson & M Wilson*
Around Devizes, *D Buxton*
Around Highworth, *G Tanner*
Around Highworth and Faringdon, *G Tanner*
Around Malmesbury, *A Wilson*
Marlborough: A Second Selection, *P Colman*
Around Melksham,
 Melksham and District Historical Association
Nadder Valley, *R. Sawyer*
Salisbury, *P Saunders*
Salisbury: A Second Selection, *P Daniels*
Salisbury: A Third Selection, *P Daniels*
Around Salisbury, *P Daniels*
Swindon: A Third Selection, *The Swindon Society*
Swindon: A Fourth Selection, *The Swindon Society*
Trowbridge, *M Marshman*
Around Wilton, *P Daniels*
Around Wootton Bassett, Cricklade and Purton, *T Sharp*

WORCESTERSHIRE

Evesham to Bredon, *F Archer*
Around Malvern, *K Smith*
Around Pershore, *M Dowty*
Redditch and the Needle District, *R Saunders*
Redditch: A Second Selection, *R Saunders*
Around Tenbury Wells, *D Green*
Worcester, *M Dowty*
Around Worcester, *R Jones*
Worcester in a Day, *M Dowty*
Worcestershire at Work, *R Jones*

YORKSHIRE

Huddersfield: A Second Selection, *H Wheeler*
Huddersfield: A Third Selection, *H Wheeler*
Leeds Road and Rail, *R Vickers*
Pontefract, *R van Riel*
Scarborough, *D Coggins*
Scarborough's War Years, *R Percy*
Skipton and the Dales, *Friends of the Craven Museum*
Around Skipton-in-Craven, *Friends of the Craven Museum*
Yorkshire Wolds, *I & M Sumner*